the best of PORTRAIT PHOTOGRAPHY

TECHNIQUES AND IMAGES
FROM THE PROS

Bill Hurter

AMHERST MEDIA, INC. ■ BUFFALO, NY

Front cover photo: Tim Kelly © 2003

Back cover photo: Martin Schembri © 2003

Published by:

Amherst Media, Inc.

P.O. Box 586

Buffalo, N.Y. 14226

Fax: 716-874-4508

www.AmherstMedia.com

Publisher: Craig Alesse

Senior Editor/Production Manager: Michelle Perkins

Assistant Editor: Barbara A. Lynch-Johnt

ISBN: 1-58428-101-4

Library of Congress Card Catalog Number: 2002113010

Printed in Korea.

10 9 8 7 6 5 4 3 2 1

Table of Contents

Photo by Joe Buissink.

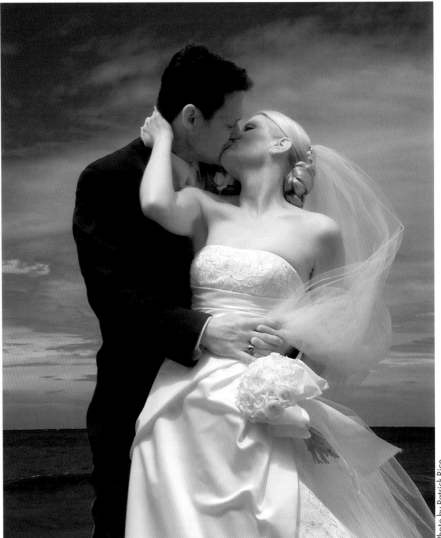

Photo by Patrick Rice.

To illustrate this book, I have called upon some of the finest and most highly decorated portrait photographers in the world. Most of the photographers included in this book have been honored consistently by the country's top professional organizations, the Professional Photographers of America (PPA) and Wedding and Portrait Photographers International (WPPI). I want to thank all of these great photographers for their participation in this book. Without them, this book would not have been possible.

In addition to the wonderful portraits you will find throughout this book, I have included a fair amount of technical information on lighting, posing, composition and camera technique to better appreciate the work of these master photographers. It is also my hope that these formal disciplines, while constantly undergoing reinterpretation, will survive and flourish as they have done before. While this book will not be the equivalent of years of portrait photography experience, it is my hope that you will be able to learn from these masters how the best portrait photography is created—with style, artistry, technical excellence and professionalism.

● THE PHOTOGRAPHERS

Michael J. Ayers (MPA, PPA-Certified, M.Photog. Cr., CPP, PFA, APPO, ALPE, Hon. ALPE)—The 2001–2 International Photographer of the Year (WPPI) and the 2001 United Nations' Leadership Award recipient, Michael J. Ayers is considered one of the best wedding album designers in the world. As the pioneer of exotic wedding album layouts such as pop-up, fold-out, and stand-up pages, he has developed an engineering discipline called album architecture, now a popular book and video! Michael was also one of the first six ANNE Award winners (PPA) and WPPI's 1997 International Portrait Photographer of the Year.

Becker—Becker, who goes by only his last name, is a gregarious wedding photojournalist who operates a hugely successful studio in Mission Viejo, CA. He has been a featured speaker at WPPI and has also competed and done well in international print competition.

Vladimir Bekker—Vladimir Bekker, owner of Concord Photography in Toronto, Canada, specializes in weddings and environmental portraits. An immigrant from the Ukraine, Vladimir took up photography when he was a boy. He is a graduate of Lvov Polytechnical University with a master's degree in architecture, which explains why many of his wedding images include architectural details. His studio photographs over a hundred weddings a year. He has won numerous international awards for his prints and albums.

David Bentley—David Bentley owns and operates Bentley Studio, Ltd. in Frontenac, MO. With a background in engineering, he calls upon a systematic as well as creative approach to each of his assignments. His thirty years of experience and numerous awards speak to the success of the system.

Joe Buissink—Joe Buissink is an internationally recognized wedding photographer from Beverly Hills, CA. Almost every potential bride who picks up a bridal magazine will have seen Joe Buissink's photography. He has done many celebrity weddings, including actress Jennifer Lopez's 2002 wedding, and is a mulptiple Grand Award winner in WPPI print competition.

Bambi Cantrell—Bambi is a highly decorated photographer from the San Francisco Bay area. She is well known for her creative photojournalistic style and is the recent co-author of a best-selling book on wedding photography, entitled *The Art of Wedding Photography* (Amphoto). Bambi is a highly sought-after speaker at national photographic conventions and schools.

Anthony Cava (B.A., MPA, APPO)—Born and raised in Ottawa, ONT, Canada, Anthony Cava owns and operates Photolux Studio with his brother, Frank. Frank and Anthony's parents originally founded Photolux as a Wedding/Portrait Studio, thirty years ago. Anthony joined WPPI

and the Professional Photographers of Canada ten years ago. At thirty-three years old, he is the youngest Master of Photographic Arts (MPA) in Canada. One of his accomplishments is that he won WPPI's Grand Award for the year with the first print that he ever entered in competition.

Robert Cavalli—Robert Cavalli is well known as master print maker. His lab, Still Moving Pictures, in Hollywood, CA, attracts the finest portrait and wedding photographers in the country. At the WPPI 2002 print competition, Cavalli had over seventy-five of his prints on display among the award-winning collection. He is also a fine photographer in his own right. He has an associate degree from FIT in New York City, studied at CUNY, also in New York City, and received an MA from the prestigious American Film Institute in Los Angeles.

Phillip Charis—Phillip Charis is regarded as one of the finest living portrait photographers. He holds degrees of Master of Photography and Photographic Craftsmen and is a Fellow of the American Society of Photographers. He is Fellow in the Institute of British Photographers and an Associate in the Royal Photographic Society of Great Britain. He has taught at the Winona School and has been a speaker at numerous state and national photographic conventions. With his wife Maryanne, Phillip Charis owns a prestigious 5000 square-foot studio on the grounds of their home, the Forster Mansion, built in 1910, in historic San Juan Capistrano, CA.

Gigi Clark—With four college degrees, Gigi Clark has a varied background including multimedia, instructional design, graphic design and conceptual art. She brings all of her multi-disciplined talents to her upscale photography business located in Oceanside, CA. She has received numerous awards and honors including several first places in both PPA and WPPI competitions, as well as the Fujifilm Award for "Setting New Trends."

Jerry D—Jerry D owns and operates Enchanted Memories, a successful portrait and wedding studio in Upland, CA. Jerry has had several careers in his lifetime, from licensed cosmetologist to black belt martial arts instructor. Jerry is a highly decorated photographer by WPPI and has achieved many national awards since joining the organization.

Stephen Dantzig (Psy.D)—Dr. Stephen Dantzig owns and operates a small commercial studio in Hawaii. His work ranges from commercial fashion to products and interiors to executive portraits.

William L. Duncan (M.Photog. CPP, APM, AOPM, AEPA)—Bill Duncan was one of the original members of WPPI with three levels of achievement. He has been a consistent winner in print competitions from all organizations, and he is known around country for his unique images. He is an instructor of "Artistry in the Language of Light" seminars.

Ira and Sandy Ellis—This team of photographers owns and operates Ellis Portrait Design in Westlake, CA. The Ellis team, in addition to twenty or so weddings a year, produces children's fantasy portraits, a type of high-end image created around an imaginative concept. Both Ira and Sandy have been honored in national print competitions at PPA and WPPI and have had their work featured in national ad campaigns.

Don Emmerich (M.Photog., M.Artist, M.EI, Cr., CEI, CPPS)—Don Emmerich is a virtuoso of the visual arts and one of the pioneers of applied photographic digital imaging. He belongs to a select group of professionals who have earned all four photographic degrees, and was chosen to be a member of the exclusive Camera Craftsmen of America society that is comprised of the top forty portrait photographers in the United States. Don has been PPA's technical editor for the past twelve years, with some 150 articles published in various magazines, nationally and internationally.

Gary Fagan (M. Photog., Cr., CPP)—Gary, along with his wife Jan, owns and operates an in-home studio in Dubuque, IA. Gary concentrates primarily on families and high-school seniors, using his half-acre outdoor studio as the main setting. At the 2001 WPPI convention, Gary was awarded WPPI's Accolade of Lifetime Excellence. He was also awarded the International Portrait of the Year by that same organization. At the Heart of America convention, he had the Top Master Print and the Best of Show. For the highest master print in the region, Gary received the Regional Gold Medallion Award at the PPA national convention ASP banquet.

Deborah Lynn Ferro—A professional photographer since 1996, Deborah Lynn calls upon her background as a watercolor artist. She has studied with master photographers all over the world, including Michael Taylor, Helen Yancy, Bobbi Lane, Monte Zucker, and Tim Kelly. Deborah is currently working toward degrees from WPPI and PPA. In addition to being a fine photographer, she is

also an accomplished digital artist. She is co-author of *Wedding Photography with Adobe Photoshop*, published by Amherst Media.

Rick Ferro (M.Photog. Cr., CPP, APM)—Rick Ferro has served as senior wedding photographer at Walt Disney World. In his twenty years of photography experience, he has photographed over 10,000 weddings. He has received numerous awards, including having prints accepted into PPA's permanent Loan Collection. He has won numerous awards from WPPI and is the author of *Wedding Photography: Creative Techniques for Lighting and Posing*, and co-author of *Wedding Photography with Adobe Photoshop*, both published by Amherst Media.

Tony Florez—For the past twenty-five years, Tony Florez has been perfecting a unique style of wedding photography he calls "Neo Art Photography." It is a form of fine-art wedding photojournalism that has brought him great success. He owns and operates a successful studio in Laguna Niguel, CA. He is also an award winner in WPPI print competition.

Frank A. Frost, Jr. (PPA-Certified, M. Photog. Cr., APM, AOPA, AEPA, AHPA)—Located in the heart of the Southwest, Frank Frost has been creating his own classic portraiture in Albuquerque, NM for over eighteen years. Believing that "success is in the details," Frank pursues both the artistry and business of photography with remarkable results, earning him numerous awards from WPPI and PPA along the way. His photographic ability stems from an instinctive flair for posing, composition, and lighting.

Elaine Hughes—Along with husband Robert, Elaine Hughes is half of Robert Hughes Photography. She has only been photographing professionally for a few years but has already achieved national notoriety. In her first-ever print competition, Elaine scored the third highest print case in the WPPI 2001 print competition and one of her images, *They Didn't Think I Would Make It*, was awarded second place in the photojournalism category.

Tim Kelly (M.Photog. Cr.)—Tim Kelly has won almost every available photography award. He not only holds degrees of Master of Photography and Photographic Craftsman, but he has amassed numerous awards: PPA Loan Collection, Kodak Gallery Award, Gallery Elite Award, and Epcot Award. Kelly, a long time member of Kodak's Pro Team, has been under the wing of their sponsorship since 1988. In 2001, Kelly was awarded a fellowship in the American Society of Photographers and was named to the prestigious Camera Craftsmen of America. Most recently, the Photography Hall of Fame in Oklahoma City has announced that it will display a Kelly portrait and an album of images in their permanent collection. Kelly Studio and Gallery in the North Orlando suburb of Lake Mary, FL, is the epitome of a high-end creative environment.

Phil Kramer—In 1989, after graduating from the Antonelli Institute of Art and Photography, Phil Kramer opened his own studio, Phil Kramer Photographers, specializing in fashion, commercial and wedding photography. Today, Phil's studio is one of the most successful in the Philadelphia area and has been recognized by editors as one of the top wedding studios in the country. Recently, he opened offices in Princeton, NJ, New York City, Washington, DC, and West Palm Beach, FL. An award-winning photographer, Phil's images have appeared in numerous magazines and books both here and abroad and he is regularly a featured speaker on the professional photographers' lecture circuit.

Kevin Kubota—Kevin Kubota formed Kubota Photo-Design in 1990 as a solution to stifled personal creativity. The studio shoots a mixture of wedding, portrait, and commercial photography. Kubota Photo-Design was one of the early pioneering studios of pure digital wedding photography in the late 1990's and began lecturing and training other photographers to make a successful transition from film to digital.

Frances Litman—Frances Litman, is an internationally known, award-winning photographer from Victoria, BC, Canada. She has been featured by Kodak Canada in a national publications and has had her images published in numerous books, magazines and in FujiFilm advertising campaigns. She was awarded a Craftsman and Masters from the Professional Photographers Association of Canada. She has been awarded the prestigious Kodak Gallery Award and she has been awarded the Photographer of the Year by the Professional Photographers Association of BC.

Tammy Loya—Tammy Loya is an award-winning children's portrait specialist from Ballston-Spa, NY. In her first WPPI Awards of Excellence print competition last year, she won a first and second place in the "children" category. All her other entries each received honorable mentions. Her studio is a converted barn, which includes a Victorian theater, known as the

Jailhouse Rock Theater, for previewing her client's images.

Rita Loy—Rita Loy is the co-owner of Designing Portrait Images, along with her husband, Doug, in Spartanburg, SC. Rita is a seventeen-time recipient of Kodak's Gallery Award of Photographic Excellence, an eight-time winner of the Fuji Masterpiece Award and she has been voted South Carolina's Photographer of the Year a record seven times. She has won awards, both national and regional, too numerous to mention. Rita is also a member of Kodak's prestigious Pro Team.

Charles Maring—Charles and Jennifer Maring own and operate Maring Photography, Inc. in Wallingford, CT. Charles is a second-generation photographer, his parents having operated a successful studio in New England for many years. His parents now operate Rlab (resolutionlab.com), a digital lab which does all of the work for Maring Photography, as well as for other discriminating photographers needing high-end digital work. Charles Maring is the winner of the WPPI 2001 Album of the Year Award.

Gene Martin—Gene Martin studied photography at the State University of Farmingdale in Long Island, NY, but spent the next fifteen years as a professional guitar player. In 1985, Martin resumed his career as a professional photographer specializing in entertainment personalities, particularly jazz musicians. He soon became one of the leading portraitists of jazz musicians in America. All of the jazz magazines have published his work, but his work has also appeared in *Time, Newsweek, People, Entertainment Weekly,* and many others.

Malcolm Mathieson—Australian photographer Malcolm Mathieson photographs weddings, a few portraits, and lots of landscapes. He also mounts the occasional exhibition. He's a Master Photographer and a well-known judge, lecturer and industry supporter. He is a past president of the Australian Institute of Professional Photography, has gained his Associateship of AIPP and the New Zealand Institute of Professional Photography, and was recently elected to the board of the World Council of Professional Photography, the first photographer from the southern hemisphere to gain such a position. He has spoken to many audiences in Australia, New Zealand, Canada, Ireland, Italy, the United Kingdom, and the U.S.

Heidi Mauracher (M. Photog. Cr. CPP, FBIPP, AOPA, AEPA)—The late Heidi Mauracher presented programs to audiences around the world. Her articles and photographic images were featured in a variety of professional magazines and books, and her unique style has earned many PPA Loan Collection prints and more than one perfect "100" in international competition. Her most recent album scored a perfect "100" in competition and won a grand award in competition at WPPI 2002. She left us in March, 2003.

William S. McIntosh (M.Photog. Cr., F-ASP)—Bill McIntosh photographs executives and their families all over the U.S. and travels to England frequently on special assignments. He has lectured all over the world. His popular book, *Location Portraiture: The Story Behind the Art* (Silver Pixel Press), is sold in bookstores and other outlets around the country.

Mercury Megaloudis—Mercury Megaloudis is an award-winning Australian photographer and owner of Megagraphics Photography in Strathmore, Victoria, Australia. The Australian Institute of Professional Photography awarded him the Master of Photography degree in 1999. He has won awards all over Australia and has recently begun entering and winning print competitions in the U.S.

Ferdinand Neubauer (PPA Certified, M.Photog. Cr., APM)—Ferdinand Neubauer started photographing weddings and portraits over thirty years ago. He has won many awards for photography on state, regional, and international levels. He is also the author of *The Art of Wedding Photography* and *Adventures in Infrared* (both self-published). His work has appeared in numerous national publications and he has been a speaker at various photographic conventions and events.

Dennis Orchard (ABIPP, AMPA, ARPS)—Dennis Orchard is an award-winning photographer from Great Britain. He has been a speaker and an award winner at WPPI conventions and print competitions. He is a member of the British Guild of portrait and wedding photographers.

Richard Pahl—Rick Pahl is a highly successful senior and portrait photographer from Okeechobee, FL. He is a digital wizard and has taught nationally on using Photoshop as a creative and production tool. He is one of the few photographers to ever score perfect 100s in both WPPI and PPA print competitions.

Larry Peters—Larry Peters is one of the most successful and award-winning senior photographers in the nation. He operates

three highly successful studios in Ohio and is the author of two books, *Senior Portraits* (Studio Press, 1987) and *Contemporary Photography* (AIPress, 1995). His award-winning web site is loaded with good information about photographing seniors: www.peters photography.com.

Norman Phillips (AOPA)—Norman Phillips has been awarded the WPPI Accolade of Outstanding Photographic Achievement (AOPA), is a registered Master Photographer with Britain's Master Photographers Association, a Fellow of the Society of Wedding and Portrait Photographers, and a Technical Fellow of Chicagoland Professional Photographers Association. He is a frequent contributor to photographic publications, a print judge and a guest speaker at seminars and workshops across the country. He is the author of *Lighting Techniques for High Key Portrait Photography*, published by Amherst Media.

Joe Photo—Joe Paulcivic III is a second-generation photographer who goes by the name of Joe Photo, his license plate in high school. He is an award-winning wedding photojournalist from San Juan Capistrano, CA. Joe has won numerous first place awards in WPPI's print competition and his distinctive style of wedding photography reflects the trends seen in today's fashion and bridal magazines. The images are spontaneous and natural rather than precisely posed.

Patrick Rice (M.Photog. Cr., CPP, AHPA)—Patrick Rice is an award-winning portrait and wedding photographer with over twenty years in the profession. A popular author, lecturer and judge, he presents programs to photographers across the U.S. and Canada. He has

won numerous awards in his distinguished professional career, including the International Photographic Council's International Wedding Photographer of the Year Award, presented at the United Nations. He is the author of *The Photographer's Guide to Success in Print Competition*, and co-author of *Infrared Wedding Photography*, both published by Amherst Media.

Ralph Romaguera and Sons—Ralph Romaguera is a highly successful senior and teen photographer with three thriving studios in the greater New Orleans area. Ralph and his sons, Ryan and Ralph Jr. (also successful photographers), operate his three studios. He can be reached via his studio's web site: www.romaguera.com.

Duane Sauro—Duane Sauro holds virtually every degree attainable from the PPA, and is an enigmatic master of portraiture. He is also the master of the mysterious portrait. He is both an artist and a technician, excelling in both the upper echelons of artistic mastery and creative communication, as well as being a superb technician, both in traditional and digital disciplines.

Martin Schembri (M.Photog., AIPP)—Martin Schembri has been winning national awards in his native Australia for twenty years. He has achieved a Double Master of Photography with the Australian Institute of Professional Photography. He is an internationally recognized portrait, wedding, and commercial photographer and has conducted seminars on his unique style of creative photography all over the world.

Kenneth Sklute—Beginning his wedding photography career at sixteen in Long Island, NY, Kenneth quickly advanced to shooting an

average of 150 weddings a year. He purchased his first studio in 1984 and soon after received his masters degree from PPA in 1986. In 1996, he moved to Arizona, where he enjoys a thriving business. Kenneth is much decorated, having been named Long Island Wedding Photographer of the Year fourteen times, PPA Photographer of the Year and APPA (Arizona) Wedding Photographer of the Year. He has won these awards numerous times as well as winning numerous Fuji Masterpiece Awards and Kodak Gallery Awards.

Jeff Smith—Jeff Smith is an award-winning senior photographer from Fresno, CA. He owns and operates two studios in central California. He is well recognized as a speaker on lighting and senior photography and the author of *Corrective Lighting and Posing Techniques for Portrait Photographers*, *Outdoor and Location Portrait Photography*, *Success in Portrait Photography*, and *Professional Digital Portrait Photography*, all from Amherst Media. He can be reached at his studio's web site: www.jeffsmithphoto.com.

Michael Taylor—Michael Taylor is the owner of Taylor Fine Portraiture in Pasadena, CA. He is highly decorated by the PPA and serves on that organization's board. Taylor is a big believer in community involvement and for twenty years has been an active member of the Junior League, an association that has led both to satisfaction and recognition in the affluent community of Pasadena.

Alisha and Brook Todd—Alisha and Brook Todd are young photographers and their studio in Aptos, CA (near San Francisco) is fast becoming known for its elite brand of wedding photojournalism.

Both Alisha and Brook photograph the wedding with "one passion and two visions." The Todds are members of both PPA and WPPI and have been honored in WPPI's annual print competition.

David Anthony Williams (M.Photog. FRPS)—David Anthony Williams owns and operates a wedding studio in Ashburton, Victoria, Australia. In 1992 he achieved the rare distinction of Associateship and Fellowship of the Royal Photographic Society of Great Britain (FRPS) on the same day. Through the annual Australian Professional Photography Awards system, Williams achieved the level of Master of Photography with Gold Bar—the equivalent of a double master. In 2000, he was awarded the Accolade of Outstanding Photographic Achievement from WPPI, and has been a Grand Award winner at their annual conventions four times.

Monte Zucker—When it comes to perfection in posing and lighting, timeless imagery and contemporary, yet classical photographs, Monte Zucker is world famous. He's been bestowed every major honor the photographic profession can offer, including WPPI's Lifetime Achievement Award. In 2002, Monte received the International Photography Council's International Portrait Photographer of the Year Award, presented at the United Nations. In his endeavor to educate photographers at the highest level, Monte, along with partner Gary Bernstein, has created a popular information-based web site for photographers, www.Zuga.net.

What is a great portrait? Or better yet, what is a *portrait*? One cannot truly know what a great portrait is before one understands what it is that defines a portrait. On its face, portraiture is a visual art form that describes a person's likeness. By that definition, every snapshot would seem to be a portrait—and that is technically correct. A portrait *is*, at its most basic roots, a description of the likeness of a person. As you will see throughout this book, however, that is the very *least* a portrait will do—and a truly great portrait will go far beyond this minimum.

● QUALITIES OF A GREAT PORTRAIT

More than a Likeness. Well respected Australian photographer Malcolm Mathieson sees the definition of a portrait somewhat differently. "When I view a portrait, I want it to communicate something of the nature of the person, not just look like someone." Malcolm created an exhibition and book entitled *Bairnsdale, An Australian Country Town*, and on opening night the work raised $8000 for the small community hospital. The exhibit, a collection of portraits, is a tribute to unsung heroes—rich and poor, young and old—from every walk of Australian country town life. Some of that work is featured in this book and it is not what one would consider, necessarily, great portraiture.

Although at first glance one would probably say they are the work of a photojournalist, if you subscribe to the definition that a portrait should convey something more than a likeness then these are truly wonderful portraits. Mathieson's work conveys the history and fabric of life in rural Australia, as well as a sense of truth and reality. These characteristics reveal two more ingredients of a good portrait, and hence a good portrait photographer—that he or she be a consummate observer and that the photographer's portraits detail some aspect of the person's life and times.

As seen in these images, a fine portrait conveys the character of the person. It is an effective glimpse into the soul of the subject. This is one of the things that separates a great portrait from a mere likeness—even a flattering one. While it is impossible to obtain a clear

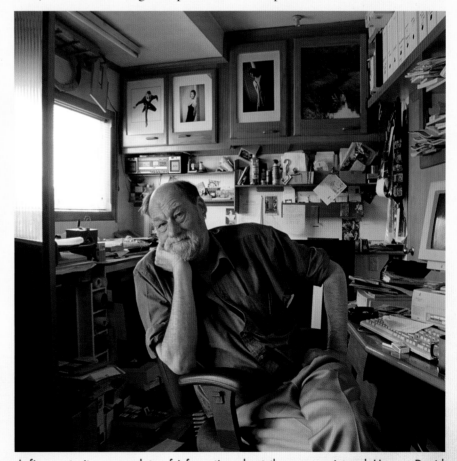

A fine portrait conveys lots of information about the person pictured. Here, a David Williams portrait reveals a great deal about the man in the photograph—his work habits, his intensity, his passion. The organized chaos that is his office invites a close inspection of each nook and cranny.

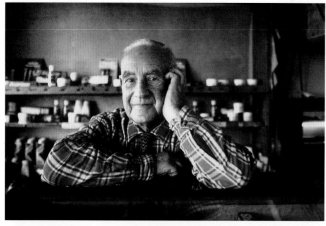

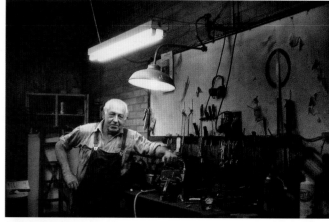

Pictured in these documentary portraits are some of the faces of Bairnsdale, an Australian village that photographer Malcolm Mathieson chronicled in a 1996 book. Featured (clockwise from top right) are Graeme Hadfield, a small engine mechanic; a couple known simply as Mr. & Mrs. Ballroom, who raise money for cancer research; a local character named Billie King; and Ray Dorrington, a barber. From within Mathieson's portraits there is a radiance and a comfort. Each person reflects a fondness for and trust in the photographer. When viewing the portraits from this book, one seems to know each of these strangers as if from a prior meeting.

understanding of a person's complex character from a single stolen moment in time, it *is* possible to convey something of a person's character, as well as their attitudes and station in life.

Beyond the Obvious. Photographer and author J.J. Allen thinks the definition of a portrait is a bit more complex. In his words, "It is an image that invites your imagination to reach beyond the obvious." He cites the example of the Philippe Halsman portrait of Sir Winston Churchill seated on the bank of a pond on his estate. Churchill's back faces the camera, "But at that time in history, his bulk and his seemingly immovable quality described the man who was one

of the world's greatest leaders." Revealing the depth of a person and an inner sense of that individual is more in keeping with what the art of portraiture is all about.

The great portraitist is one who sees things others don't. This can obviously be said of any artist, visual or otherwise, but the portrait artist has to appraise and apprise in a manner of seconds, plotting a visual course that will reveal what he or she has seen and wants to reveal. A great portrait photographer sees a great many aspects of a person in a split second. This is perhaps the greatest gift a photographer can possess—and it is rare, even among successful portrait photographers.

Artistic Quality. Tim Kelly, a modern-day master, says, "Watch your subjects before you capture the image. Sometimes the things they do naturally become great artistic poses." For this reason, Kelly does not warn his clients when he is ready to start a portrait session. "I don't believe in faking the spontaneity of the subject's expression," Kelly says. Tim Kelly's portraits are soft, elegant and relaxed. They have the mark of an artist who is a great observer but also the mark of a great designer. Aside from their outer beauty, Kelly's portraits exhibit a naturalness and spontaneity uncommon in posed portraits. In Kelly's words, "What matters is that my rendering

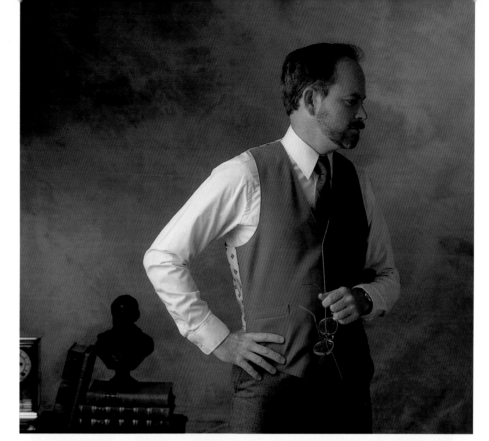

TOP—Titled *A Classic Decision*, this is a casual but very structured pose wherein the subject has turned away from the light—a most unusual format for a portrait. His attention is focused outside the confines of the portrait. The image is minimally propped—a small bust, a few books, and a curious half of a clock. There is meaning and obscurity in the image, but it is also beautifully done in that it is an elegant study in brown tones. The portrait, at this level, communicates so much more than mere surface details. Portrait by Tim Kelly. BOTTOM—Bill McIntosh photographs many of his fine portraits in his subject's homes, which are often quite luxurious. He will meet with his subjects prior to the sitting and plan the location and elements for each portrait. Bill believes that these elements are vitally important to the image and so they are carefully lit and always in razor sharp focus. The result is an "important" portrait that the client will often purchases as a wall-size portrait in a fine frame.

of the subject is the best interpretation that can be made. I think my work is artistic, but I do not consider it creative. The creation is the subject."

Kelly, in his studio handbook, further defines his perception of the fine portrait: "An artistic portrait should command attention, make an artistic statement or trigger an emotional response from the viewer." He adds, "A fine-art portrait transcends time. It goes far beyond the utilitarian uses of the subjects, the people portrayed."

Enlivening. An accomplished portrait photographer is able to make a positive connection with people, time after time. The cliché of being a "people person" rings true here, but more than that, the portrait photographer is able to connect with people on a physical and emotional level so that when their portrait is made, there is a communication happening beyond

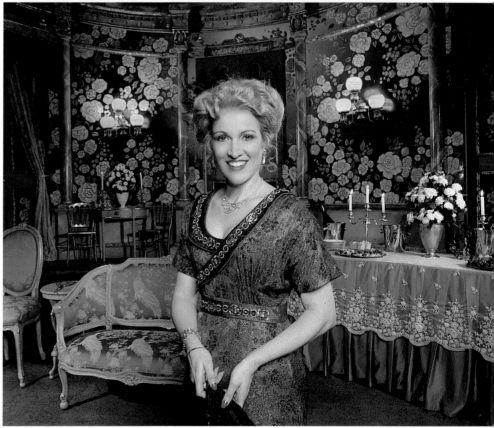

and without words. Perhaps it's no more than empathy, but beneath that the photographer must have a strong desire to bring the best out of his or her subjects—to make

them look their finest and to bring out the best in them emotionally.

Artists like Bill McIntosh, an expert portrait photographer for more than fifty years, sees one of

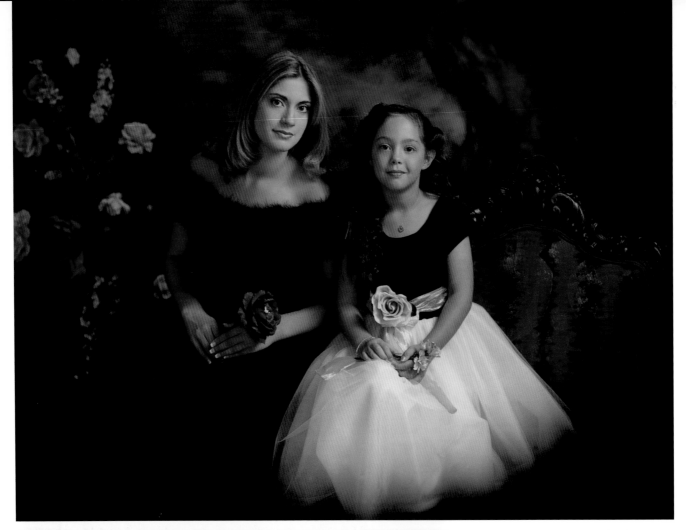

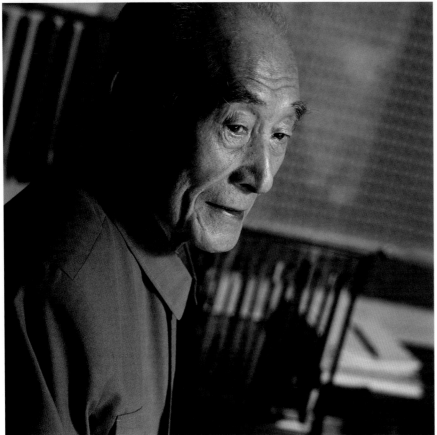

LEFT—Portraits by David Williams contain what he calls "a life force." In this portrait, printed in the rich tradition of the salon black & white portrait, a grid-work of diagonals in the out-of-focus background contrasts with the simplicity of the subject's pose and clothing. The rich highlight detail draws your attention to the man's eyes, which seem to convey a deep sense of time and knowledge. ABOVE—Phillip Charis believes in the formal portrait, in which a sense of style conveys the relevant information about the subject. Here, a subdued background and minimal props allow the beauty of the subjects to be conveyed. Charis's expressions are subtle and the posing conveys as much about the people as the expressions. In this image, the hands are nearly as expressive as the eyes.

the keys to his success as his ability to enliven his subjects, developing an endearing kind of rapport. His tools of the trade are "outrageous flattery and cornball humor." He rarely stops talking and makes the subject part of the reverie and good time. The expressions he elicits from otherwise staid customers are oftentimes priceless.

One of my favorite photographers is David Anthony Williams, who summed up what great portraiture is all about when speaking to a group of print judges at an international print competition. He said, "Our photography is about life. Is there a life force in the image or has the subject been there too long?" The life force he refers to is the lingering and overpowering side effect of portraiture that keeps the affected coming back for more. In great portraiture we rediscover what it is that makes us feel alive and great, both individually and collectively. And we rediscover what it is that makes us all human and vulnerable and what it is that makes us laugh and cry.

Style. Phillip Charis, one of the finest portrait photographer of this century sees portraiture as being about discernable style. In the introduction to his book, *A Lasting Tradition*, he says, "Merely capturing the superficial likeness of a subject is not enough for me; nor should it be for more discerning patrons. Style is what counts above all, and style is what allows the artist to fully express himself and the client to be amply revealed and honored." While not discounting the photographer's skills as a trained observer, this view of portraiture adds the element of style and includes the "formal elements" found in traditional portraiture throughout the centuries.

This school of thought underscores the belief that the sitter should be pictured in a serious manner and that the photographer should enhance the formality and elegance of the portrait. Like the great portrait painters of the Victorian era, the formal portrait photographer seeks to coordinate all of the formal elements of the picture. The background is selected to complement the skin tones and the clothes (often referred to as "the costume"), and this helps set the mood of the portrait. With these elements under the control of the photographer, he or she can then address the pose, the expression, and what Charis refers to as "the final judgment of the portrait," meaning the photographer's imprint of final pose and gesture of the subject—the result being the one image that defines the person for the ages.

Bill McIntosh has an equally serious view of fine portraiture. "I treat my portraits as if they are paintings. For the right client, I present them the same way painters display their finished work. I bring the completed custom-framed portrait to the home, with an easel and picture light. The framed portrait is in a red velvet bag and at the right time I unveil the portrait."

McIntosh believes that portrait photographers of today owe a great deal to the portrait painters of the Victorian era. The reign of Queen Victoria (1837–1901) was a time when Great Britain's global dominance and subsequent industrialization produced a large and wealthy middle class that was able to procure the trappings of wealth, like fine homes, furnishings, and art. In McIntosh's view, "The new middle class wanted the best of everything and they could afford it. High on their list was paintings of themselves and their families. At no time in history was the portrait painter more in demand, celebrated, and

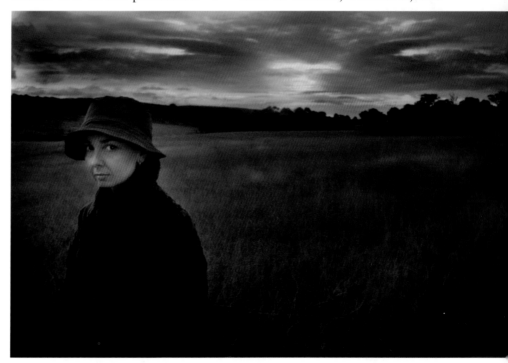

Martin Schembri believes in telling a story with each portrait. Here the unusual landscape, rich in saturated color, holds the subject as part of its power. Unusual positioning of the subject conveys a sense of journey, perhaps much of it already completed. And her expression reveals a sense of overwhelming emotion.

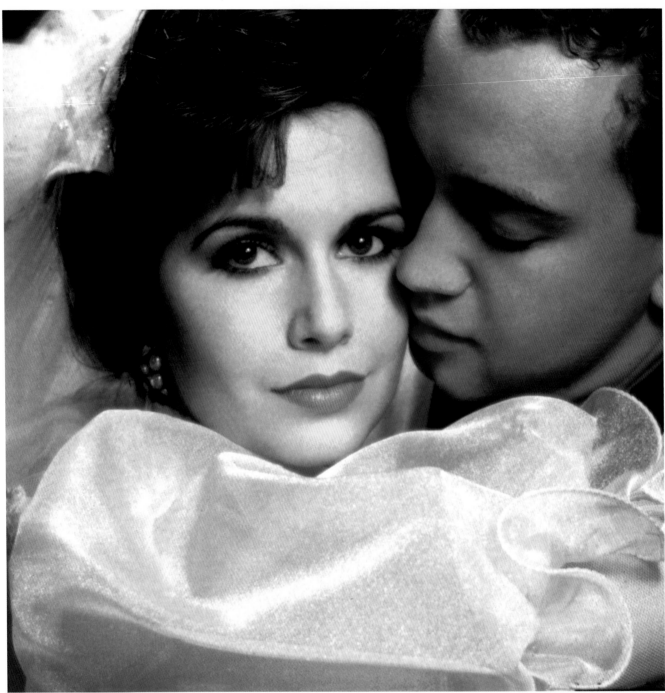

Monte Zucker's portraits are timeless and elegant. This image was made almost twenty years ago and uses intimate posing to reveal the graceful beauty of this bride. The groom is a supportive character whose gaze, pose, and tonality serve to direct the viewer's attention solely on the bride. Monte is also a master of formal lighting. Here, the richly detailed highlights and smooth transition to shadow make this a memorable and dramatic portrait.

financially rewarded than during the Victorian era. The Victorian painters supplied this art for their patrons and during this time the flattering portrait was perfected. The poses, lighting, storytelling genre scenes, and innovative uses of color and design were realized."

Both Bill McIntosh and Phillip Charis continue the formal portrait tradition today. Charis says that what he creates are essentially formal portraits. Whether the subject

is a movie star or stay-at-home mom, Charis's portraits show people at their finest—wearing fine jewelry, the best clothes. The subjects are idealized and regal, displaying a kind of old-world charm and formality.

Portraits as Memories. On another of its most basic levels, the portrait is a means to remembering—a memory. "This is how sister Jeanne looked when she was eleven—she still has that impish

grin fifty years later!" This function of the portrait, while on the surface mundane, is no less important than the view of the portrait as psychological profile, historical tapestry or any other of its popular definitions.

Portraits taken in the home define not only an environment, but also the history of the family members recorded there. It is important that detail be vivid in home portraits, as these are the things that will be treasured in years to come. If the photographer combines the historical aspects of home with an emotional rendering, then he or she will have created a portrait of great lasting value.

Many of us see the contemporary portrait as a sort of time capsule, a storytelling device that holds treasured totems of a time that may be lost someday soon.

Monte Zucker, who is recognized as one of the finest portrait and wedding photographers in the world, combines a number of notions into his concept of the fine portrait. He says, "A Monte portrait is simple, elegant, void of distractions and usually flatters the subject. It makes a statement mostly about the subject, but at the same time includes my interpretation of that person."

Monte shows his subjects naturally and often in a relaxed setting, but just as often, his portraits depict

Martin Schembri recreated an era of portraits made as charcoal drawings by creating this monochromatic, very grainy image of bride and groom. As in the portrait by Monte Zucker shown on the facing page, the groom is almost unimportant to the image except to convey the emotion that exists for her. The pictures hung from the ceiling molding, the antique loveseat and the bowl of fruit on the window ledge all support the sense that this is a timeless image from long ago.

people as he would like them to be. He idealizes his sitter when he feels it is appropriate. "Either way," he says, "it is a simple statement. I want the viewer to *feel* a Monte portrait as well as *see* it. If you are emotionally connected with my subjects when you see their portraits, I feel that I have done my job."

Monte, who has always been ahead of the curve in predetermining what the public wants, has touched a popular nerve. Like the popularity of the wedding photo-

journalist, who brings out the hidden emotion of the wedding day, the good contemporary portrait photographer must also reveal those inner emotions. A good portrait can't just be about classical composition or rich colors. It must strike a nerve, spark an emotion. In the words of one successful studio manager, "If they cry, they buy."

Human Condition. Still others portrait artists choose to tell a tale of the human condition, using the portrait subject as the vehicle for a higher plane of communication.

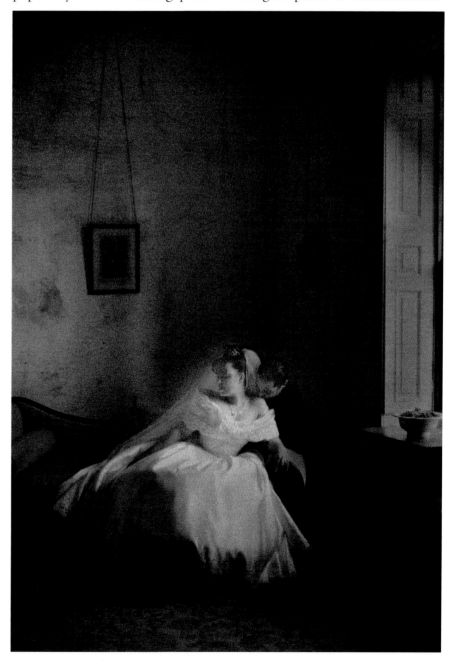

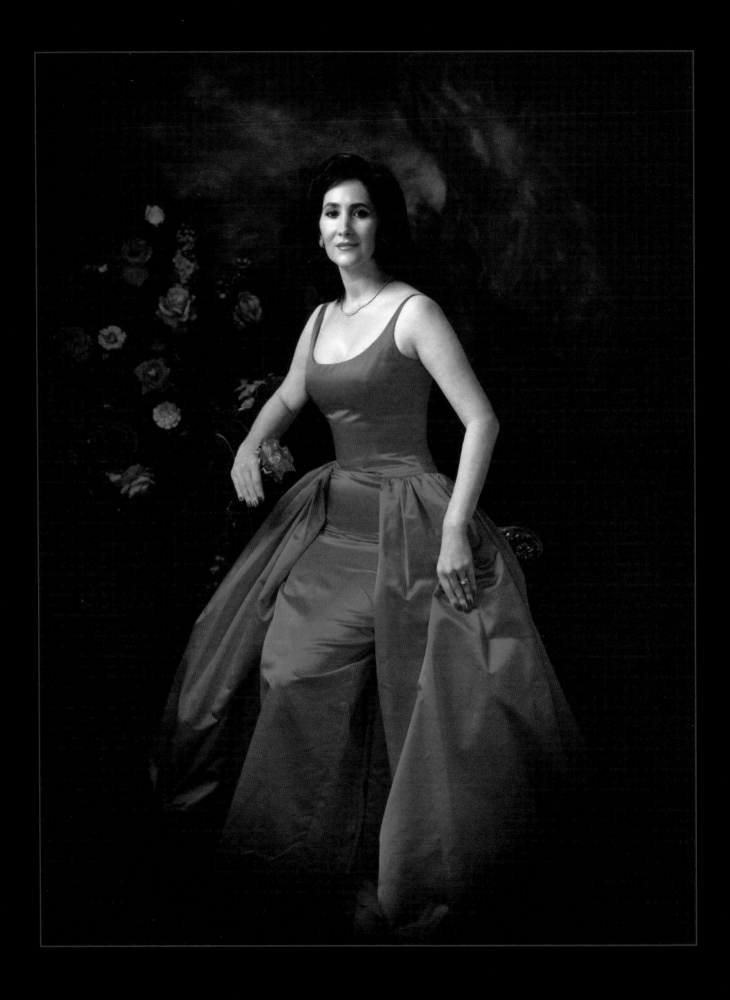

Yet, even at its most basic level, the portrait is an ingenious storytelling device—whether it be the future of endless possibilities seen in a high school girl's hopeful gaze or the stoic intensity of a modern-day soldier pictured in full military dress. The portrait is so literal and yet it invites the imagination to probe and find deeper understanding and meaning.

Idealization. There are other definitions, certainly, of a fine portrait. A popular one is that a portrait is a likeness that comes close to the person's own self-image; flattering and idealized. This is particularly relevant since portraiture is, by necessity, a commercial endeavor. People who pay large fees for their portraits must not only be happy with the outcome, but also be flattered by the likeness.

Size. According to some, the portrait's importance depends in part on its being close to life-size, an aspect that may be determined in part by where the image would be hung in the home. Along with the ornate frame—often gilded with intricate scrollwork—this type of portraiture is in the grand tradition. These portraits also keep alive intangibles that are not always found in contemporary life—elegance, dignity, and grace.

● TECHNICAL QUALITIES

Expression. The expression is all-important in the fine portrait. While a gifted photographer is capable of producing literally dozens of saleable portraits in a single sitting, there is always one portrait that stands above the rest, and its high caliber is usually related to the expression. Many great portrait photographers believe the expression must be "tranquil," so as to provide a glimpse into the subject's mind and character. The expression should also be compelling, causing the viewer to gaze into the eyes of the portrait, appreciating the uniqueness of the person and the image.

Often, the compelling nature of a portrait is related to the gaze of the subject. He or she may be looking into the camera, but is, by extension, looking out at the viewer in a way that invites both inquiry and understanding. All clichés aside, the eyes are the most interesting and alluring part of the human face, allowing the viewer to become totally absorbed in the portrait.

Attention to Detail. As important to the portrait as the expression are the details of the portrait. The nuances of pose, the blending of tones to form a cohesive palette and a myriad of other technical and aesthetic details contribute towards the successful fine portrait. Master photographer Phillip Charis has often said that he is obsessed with the details, believing that if the details are handled well, the closer the portrait will be to perfection. This concentration on the details is even more critical with the ability to render near life-size portraits. Says Charis, "In a small desk-size portrait, what difference does it make if a finger or wrist is bent awkwardly? What difference does it make if the placement of one person appears too close to another? In a small portrait, it's a matter of small impor-

tance. In a life-size portrait, it's of extreme importance."

Posing, Lighting and Composition. The great portrait also has a tradition of classical elegance built on a system of posing, lighting, and composition that goes back to the cave paintings of early civilization—the earliest rendered portraits. There must be a pleasing sense of simplicity, design, and an orderliness that has come from generations of perfecting the medium.

The most wonderful aspect of the portrait, whether it is contemporary or from the eighteenth century, is that it can be all of these things or none of them. It can be an homage or a completely new form or approach. But what makes portraiture compelling for the ages is that we never cease redefining how we see ourselves. The portrait will always be a popular and contemporary art form. Like Narcissus, we never tire of seeing our own endless reflection.

FACING PAGE—The fine portrait is elegant, and in the words of Phillip Charis, "tranquil." A 40" x 60" framed portrait of this image hangs in the *Rangefinder* offices, where I work. I see it every day and each day I glean a different feeling from it and I could swear that she looks different on certain days—as if the portrait has different moods. It is a compelling image and one that brings great appreciation for its artistry.

2. Posing

At the heart of any great portrait photographer's body of work is a complete and thorough understanding of the rules of posing and composition. No doubt, these rules were passed on when the photographers in this book were just getting started or were assisting other photographers. While it has become fashionable to break as many rules as possible regarding classical posing, it is also a sign of finesse to know which rules to break and when.

In any discussion of subject posing, the two most important elements are that the pose appear natural (one that the person would typically fall into) and that the person's features be undistorted. If the pose is natural and the features look normal, perspective-wise, then you have achieved your goal and the portrait will be pleasing to you and the subject. While every rule of posing could not possibly be followed

The turn of the shoulders, called the shoulder axis, creates a flattering line to the human body. The turn of the neck, called the neck axis, usually differs from that of the shoulders and also creates a flattering line and sense of direction in the portrait. In this lovely portrait of mother and daughter, Bill Duncan created a very simple but pleasing pose that flatters both women. Note that in both poses the head is tipped toward the near shoulder, a decidedly feminine pose.

in every portrait, these rules exist to provide a framework for portraying the human form naturally, attractively, and without distortion.

● HEAD AND SHOULDERS AXIS
The first fundamental of good portraiture is that the subject's shoulders should be turned at an angle to the camera. To have the shoulders facing the camera straight on makes the person look wider than he or she really is and is commonly referred to as a "mug shot" (although in the world of fashion you see this pose quite often). With

men, the head is generally turned in the same direction as the shoulders. With women, the head is often at a slightly different and opposing angle.

● TILTING THE HEAD
Your subject's head should be tilted at a slight angle in literally every portrait. By doing this, you slant the natural line of the person's eyes. When the face is not tilted, the implied line of the eyes is straight and parallel to the bottom edge of the photograph, leading to a static composition. By tilting the person's

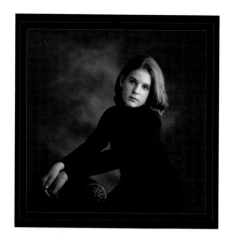

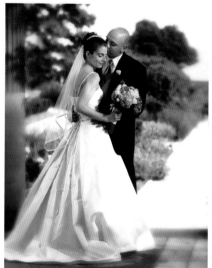

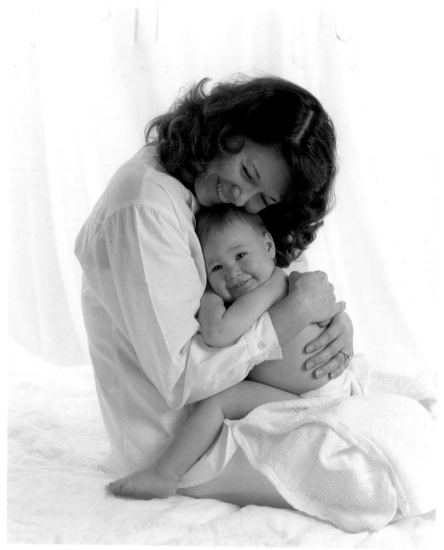

face right or left, the implied line is diagonal, making the pose more dynamic.

● THE TRIANGLE BASE

The subject's arms, regardless of how much of the subject is showing in the final portrait, should not be allowed to fall to the subject's sides, but should project outward to provide gently sloping lines and a "triangular base" to the composition. This is commonly achieved by asking the subjects to separate their arms, away from their torso, creating a bend in the elbows. This triangular base in the composition attracts the viewer's eye up toward the subject's face and is a basic element of all portraiture. Another way to accomplish the triangular base is with a posing table on which the far elbow can be rested. This

ABOVE—In this high-key portrait by Norman Phillips, you can see the effectiveness of the triangular base formed by the line of the back and legs of the mom. The triangle draws the viewer's eye upward toward the faces. Another pleasing aspect of this portrait is the implied line created by the tilt of the mother's head and the angle of the baby's face and outstretched leg. When seen in its entirety, the line approximates an S shape, one of the most pleasing of all compositional elements. TOP LEFT—Deborah Lynn Ferro created a lovely portrait of this young girl. Note that the shoulders are turned at a 45-degree angle to the camera and the girl's head is tipped back toward the near shoulder in a "feminine" pose. The angle at which the young girl's head is tipped roughly approximates the angle of her arms, and the pose creates a beautiful triangular base, one of posing's basic elements. BOTTOM LEFT—Award-winning wedding photographer Charles Maring created this elegant full-length portrait by devising an intimate pose. Notice the sloping lines of the shoulders. They are different from one another, but neither is parallel to the ground, which can cause a static line in the composition. The triangular shape of the wedding gown forms the base and forces the viewer's eye up to both faces, which are at opposing but flattering angles.

provides the sloping line of the shoulders and creates the triangular base so vital to good composition. The posing table is usually draped with black felt or velvet and nearly invisible in the final portrait.

● SLOPING LINE OF THE SHOULDERS

Whether the subject is seated or standing, another fundamental is the line of the shoulders. One shoulder should be higher than the other. The line of the shoulders

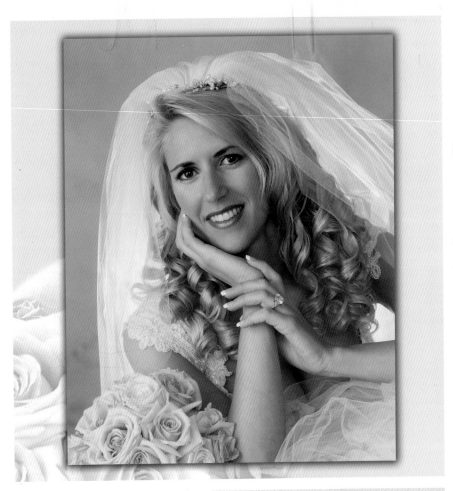

While there is considerable debate over the relevance of the terms "masculine" and "feminine" poses, they are understood by most portrait photographers to mean a pose containing certain basic elements. In the masculine pose the head and body are turned in the same direction. The head is tipped toward the low shoulder.

In the feminine pose, the head is turned and tipped toward the high shoulder. The body is leaned forward at the waist and is then tilted slightly in the opposite direction from the way the face is turned. For example, if the subject is looking to the left shoulder, the body should lean slightly to the right.

For profiles, both men and women should be placed in a feminine pose, because a face in profile needs the support of the body turned at an angle to the camera.

ABOVE—In a beautiful album page by Heidi Mauracher the feminine pose is exemplified. Note the head tipped toward the near shoulder and the beautiful sloping line of the shoulders. Also notice the beautiful hand posing—the edges of the hand are photographed and the graceful fingers are separated by a small amount of space. The hand posing is elegant and graceful, and the bride's ring is shown off to perfection. Notice that the bride is not really resting her chin on her hand—it is an effective illusion of the pose. RIGHT—In this groom's portrait by Heidi Mauracher, notice that the groom's head is tipped toward the far shoulder in a masculine pose. By tilting the image on the page of the album, the photographer further increased the angle of the tilt for a more dynamic composition.

● THREE-QUARTER- AND FULL-LENGTH POSES

The more of the human body you include in a portrait, the more problems you encounter. When you photograph a person in a three-quarter or full-length pose, you have arms, legs, feet, hands, and the total image of the body to contend with—not to mention, the all-important expression of the subject.

A three-quarter-length portrait is one that shows the subject from the head down to a region below the waist—usually mid-calf or mid-thigh. The area where the body passes out of the edge of the frame is of particular concern in this type of portrait. To avoid creating an unnerving psychological impact on the viewer, you should never compose a portrait so that the edge of the frame falls at a joint—an elbow, a knee, or an ankle, for instance.

should not be parallel to the ground. This may be achieved in any number of ways. For instance, in a standing portrait, simply instructing the subject to place his or her weight on their back foot will create a gently sloping shoulder line. In a seated head-and-shoulders portrait, having the subject lean forward from the waist will create a sloping line to the shoulders, provided that the person is at an angle to the camera.

Heidi Mauracher created this lovely full-length portrait. Both the bride and the groom have their weight on their back legs. The bride's extended front leg creates a lovely line to the gown; the groom's extended front leg mirrors the angle of the bride's leg and accentuates the crease in his pants. The composition and posing look carefree and relaxed, but each aspect is controlled, as is the placement of the dogs and the selection of the location.

A full-length portrait shows the subject from head to toe, usually with a fair amount of background or environment included in the portrait. Whether the person is standing or sitting, it is important to remember to slant the person to the lens and to create a triangular base. Avoid photographing the person head-on, as this adds mass and weight to the body and minimizes the possibility of dynamic lines in the composition. Dynamic lines—diagonal lines, triangles and other asymmetrical shapes—create visual interest within a portrait or grouping and should be an intentional aspect of any pose.

The subject's body should be positioned at a 30- to 45-degree angle to the camera. Weight should always be placed on the back foot, rather than being distributed evenly on both feet or, worse yet, on the front foot. There should be a slight bend in the front knee if the person

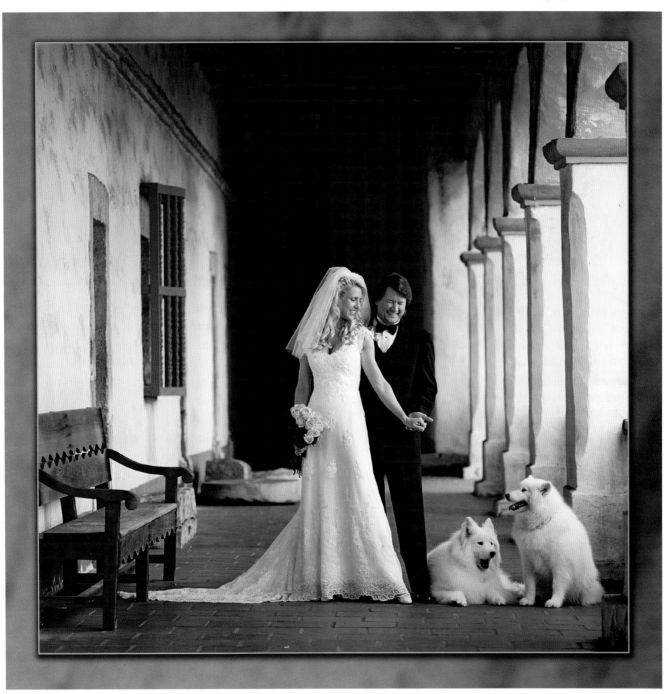

ABOVE—In this classic three-quarter-length seated pose, Heidi Mauracher has created an elegant portrait. Although the bride's shoulders are not at an angle to the camera, her body is angled beautifully and the line of the gown creates a well defined triangular base. Her hands are posed elegantly and her arms are kept away from the body so as not to add bulk to her form. Note that the direction of the portrait contrasts the direction of the painting above, creating an imbalance known as tension. RIGHT—Rick Pahl created this richly detailed portrait reminiscent of the last century. The gentleman's hand is posed to perfection. The bottom edge of the hand is showing and the fingers are staggered in an ascending manner to show separation and shape. It looks like Rick gave the man something to place in his hand to give it more roundness and overall shape.

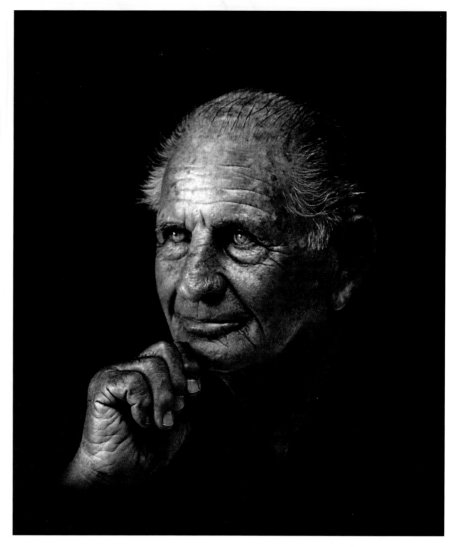

is standing. This helps break up the static line of a straight leg. If the subject is wearing a dress, a bend in the front knee will also help create a better line to the dress. The back leg can remain straight, since it is less noticeable than the front leg.

● POSING HANDS

A person's hands are often a strong indicator of character, just as the mouth and eyes are. Posing hands properly can be very difficult because in most portraits they are closer to the camera than the subject's head, and thus appear larger.

One thing that will give hands a more natural perspective is to use a longer-than-normal lens. Although holding the focus of both hands and face is more difficult with a longer focal length lens, the size relationship between them will appear more natural. Additionally, if the hands are slightly out of focus, it is not as crucial as when the eyes or face are soft.

One basic rule is never to photograph a subject's hands pointing straight into the camera lens. This distorts the size and shape of the hands. Always have the hands at an angle to the lens. Another basic is to photograph the outer edge of the hand whenever possible. This gives a natural, flowing line to the hand and eliminates the distortion

that occurs when the hand is photographed from the top or head-on.

The following suggestions give you a few additional elements to keep in mind as you pose your subjects' hands.

1. Always try to "break" the wrist, meaning to raise the wrist slightly so there is a smooth bend and gently curving line where the wrist and hand join.
2. Always try to photograph the fingers with a slight separation in between. This gives the fingers form and definition. When the fingers are close together, they appear as a two-dimensional blob.
3. When photographing a man's closed hand it is recommended

to give him something small, like the top of a pen, to wrap his fingers around. This gives roundness and dimension to the hand so that it doesn't resemble a clenched fist.

4. As generalizations go, it is important that the hands of a woman have grace, and the hands of a man have strength.

Remember that placement of hands is very important and can be a key to an effective portrait. Flat hands are unattractive. Fingers turned in on a flat hand can look like claws. Be sure to have the subjects extend their fingers so that they are long and graceful, with the edge of the hands toward the camera. Assure the sitter that what may seem or feel awkward to them comes across as quite natural from the camera's viewpoint.

Posing Hands in Group Portraits. Hands can be a problem in small groups. Despite their small size, they attract attention to themselves, particularly against dark clothing. They can be especially problematic in seated groups, where at first glance you might think there are more hands than there should be. A general rule of thumb is to either show all of the hand or none of it. Don't allow a thumb, or half a hand or a few fingers to show. Hide as many hands as you can behind flowers, hats or other people. Be aware of these potentially distracting elements and look for them as part of your visual inspection of the frame before you make the exposure. One trick for men is to have them put their hands in their pockets. A variation is for them to "hitch" their thumb outside the pocket, which forms a nice triangular shape in the bent arm and indicates to the viewer that the

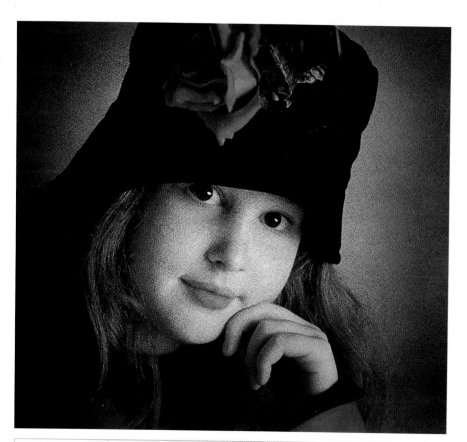

TOP—Norman Phillips has created a fine portrait of a young lady and employed excellent hand posing. Note the "break" to the wrist that gently angles in, leading the viewer's eye upward towards her face. Also, the fingers are curled delicately and deliberately to show form and separation. BOTTOM—Hands and large groups can be a disaster. Notice how the adults in the second and third rows have their hands either hidden from view or at rest in their laps and out of the view of the lens. Norman Phillips did an expert job of making sure that all (and only) the kids' hands are visible. A problem that often occurs when photographing groups is that you have too few or too many hands for the number of people photographed.

hand is in a pocket. For women, try to hide their hands in their laps or by using other people in the group.

Three-Quarter- and Full-Length Poses. When the subject is standing, the hands become a real problem. If you are photographing a man, folding the arms across his chest is a good strong pose. Re-member, however, to have the man turn his hands slightly, so the edge of the hand is more prominent than the top. In such a pose, have him lightly grasp his biceps—but not too hard or it will look like he is cold and trying to keep warm. Also, remember to instruct the man to bring his folded arms out from his body a little bit. This slims down the arms, which would otherwise be flattened against his body and appear larger. Remember to sepa-rate the fingers slightly.

With a standing woman, one hand on a hip and the other at her side is a good standard pose. Don't let the free hand dangle, but rather have her twist the hand so that the outer edge shows to the camera. Always create a break in the wrist for a more dynamic line.

● FEET
Feet should not point into the cam-era lens. They should be at an angle to the camera. Just as it is undesir-able to have the hands facing the lens head-on, so it is with the feet— but even more so. Feet tend to look stumpy and large when pho-tographed head-on.

● SEATED SUBJECTS
When the subject is sitting, a cross-legged pose is desirable. Have the top leg facing at an angle and not aimed into the camera lens. When a woman is seated, it is a good idea to have her tuck the calf of the front leg in behind the back leg. This reduces the size of the calves, since the back leg, which is farther from the camera, becomes the most prominent visually. This is a pose women fall into somewhat natural-ly. Always have a slight space between the leg and the chair, where possible, as this will slim thighs and calves.

● HEAD POSITIONS
Seven-Eighths View. There are three basic head positions in por-traiture. If you consider the full face as a head-on type of "mug shot," then the seven-eighths view is when the subject's face is turned just slightly away from camera. In other

A head-on view in which both ears are visible is usually a no-no, but here Monte Zucker makes the pose work perfectly. The main emphasis of the portrait is the model's eyes, her lips and the colorful bouquet. Her ears are out of focus and thus, not a distraction. Focus falls off past the plane of the eyes, riveting the viewer's attention on crucial elements of the portrait—the "mask" of the face and the bouquet.

ABOVE—In a seven-eighths view, you see slightly more of one side of the face than the other and the far ear is still visible to the camera. Here, Monte Zucker isolated the mask of the face by using Photoshop to defocus all but the frontal planes. It is a technique reminiscent of large format portraiture in which only a very shallow band of sharp focus is discernable. LEFT—This classic three-quarter view by Deborah Lynn Ferro is exceptionally well posed. Note the sloped line of the shoulders and the careful but very masculine posing of the hands, which is important in a senior portrait. The arms are crossed loosely so that there is no tension in his muscles. In the three-quarter view, most of the far side of the face is not visible. It is an ideal pose for dramatic lighting as was done here. Notice the background light creating a subtle highlight on the subject's neck.

words, you will see a little more of one side of the face than the other when looking through the viewfinder. You will still see, however, the subject's far ear in a seven-eighths view.

Three-Quarters View. In the three-quarters view, the far ear is hidden from the camera and more of one side of the face is visible. Because of its distance from the camera, the far eye will appear smaller than the near eye. Because people usually have one eye that is slightly smaller than the other, you can actually minimize this effect by positioning your subject so that the smallest eye is closest to the camera. This will make both eyes appear, perspective-wise, the same size in the photograph.

Many photographers do not make a distinction between the three-quarters and seven-eighths facial views. Instead, if the pose is not either a profile or a head on shot, they call it a two-thirds view. Whether you call it a two-thirds or three-quarters viewpoint, this view is probably the most used and the most versatile angle at which to photograph the human face. Keep in mind that, when employing this angle, it is important that the eye on the far side of the face be contained within the face by a small strip of skin visible along the far temple.

Profile. In the profile, the head is turned almost 90 degrees to the camera and only one eye is visible. In posing your subject in a profile position, have him or her turn their head gradually away from the camera position just until the far eye

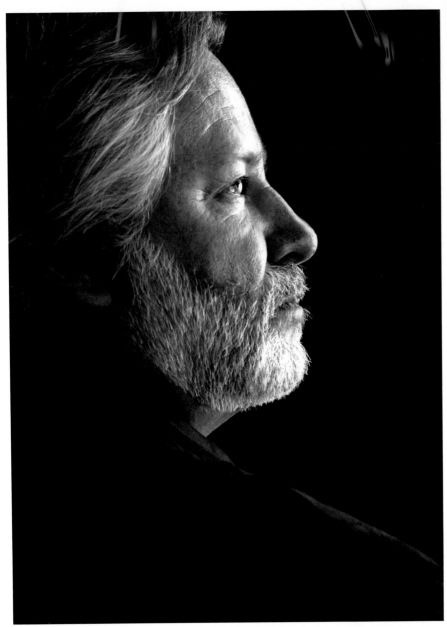

A Monte Zucker portrait has a distinctive flair as exemplified by this profile. The shoulders are turned so that the subject's back faces the camera. Monte used the extended line of the near shoulder and arm to create a long, elegant, diagonal line that leads you up to the subject's face. His head is tipped slightly back toward the camera, but not so much as to cause unsightly folds in the neck. The chin is raised and the gaze of the eyes adjusted back slightly toward the camera position so that the majority of the near eye is visible to the camera.

avoid the dreaded "mug-shot" look.

● CAMERA HEIGHT AND PERSPECTIVE

When photographing people with average features, there are a few general rules that govern camera height. These rules will produce normal perspective with average people.

1. For head-and-shoulders portraits of average subjects, the rule of thumb is that the camera should be at the same height as the tip of the subject's nose. When the front of the face is parallel to the plane of the film, the camera records the image from its best perspective.
2. For three-quarter-length portraits, the camera should be at a height midway between the subject's waist and neck.
3. In full-length portraits, the camera should be the same height as the subject's waist.

In each case, the camera is at a height that divides the subject into two equal halves in the viewfinder. This is so that the features above and below the lens/subject axis are the same distance from the lens, and thus recede equally for "normal" perspective. As the camera is raised or lowered, the perspective (the size relationship between parts of the photo) changes. By controlling perspective, you can alter the physical traits of your subject.

By raising the camera height in a three-quarter or full-length portrait, you enlarge the head-and-shoulder region of the subject, but slim the hips and legs. Conversely, if you lower the camera, you reduce the size of the head, and enlarge the size of the legs and thighs. Tilting the camera down when raising the

and eyelashes disappear from view. In some cases, most often with women, you will still be able to see the eyelashes of the far eye when the subject is in profile. Instead of turning the head further to eliminate the eyelashes, retouch them out later.

With all of these head poses, the shoulders should be at an angle to the camera. The only exception is when you want to emphasize the mass of the subject, such as an athlete, or when the person is very thin or petite. In that case, picturing them head-on will create the desired effect. Even when photographing someone head-on, however, the face should be slightly turned to one side or the other to

camera, and up when lowering the camera increases these effects. A good rule of thumb is that, for three-quarter- and full-length portraits, you should keep the lens at a height where the plane of the camera's back is parallel to the plane of the subject. If the camera is tilted upwards or downward you will add distortion.

The closer the camera is to the subject, the more pronounced the changes in perspective will appear. If you find that there is no apparent change after you make a camera-height adjustment for a desired effect, move the camera in closer to the subject and observe the effect again.

When you raise or lower the camera in a head-and-shoulders portrait, the effects are even more dramatic. Raising or lowering the camera above or below nose height is a prime means of correcting facial irregularities. Raising the camera height lengthens the nose, slims the chin and jaw lines, and broadens the forehead. Lowering camera height shortens the nose, de-emphasizes the forehead, and widens the jaw while accentuating the chin.

● FOCAL LENGTH AND PERSPECTIVE
Head-and-Shoulders Portraits. If you use a "normal" focal-length lens (50mm in 35mm format, 75–90mm in the medium formats) you have to move too close to the subject to provide an adequate image size for a head-and-shoulders portrait. This close proximity to the subject tends to exaggerate the subject's features—the nose appears elongated, the chin often juts out, and the back of the subject's head may appear smaller than normal. The phenomenon is known as foreshortening.

Portraiture, therefore, demands that you use a longer-than-normal lens on your camera, particularly for head-and-shoulders portraits. The short telephoto provides a greater working distance between camera and subject while increasing the image size to minimize distortion. The rule of thumb is to choose a lens that is twice the diagonal of the film you are using. For instance, with the 35mm format, a 75mm to 85mm lens is a good choice. For the 2¼" square format (6x6cm), a 100mm to 120mm lens is fine. For 2¼" x 2¾" cameras (6x7cm), 110mm to 135mm lenses are acceptable.

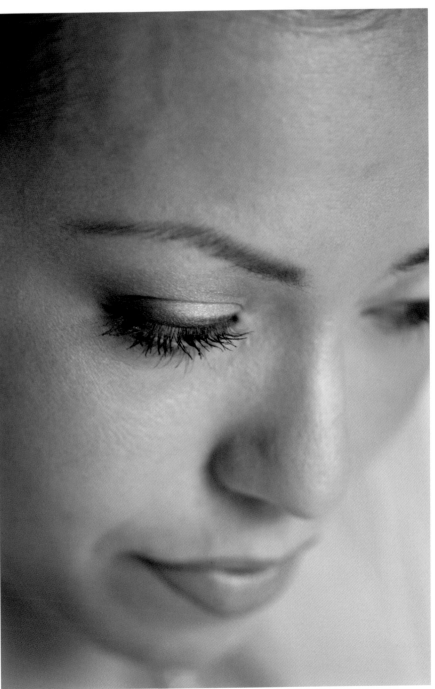

Joe Photo created this delicate portrait by using a telephoto lens, a 135mm on a 35mm Nikon camera, at close range and at a wide lens aperture for minimal depth of field. The close-up working distance does not alter the perspective of the face, and it allowed Joe to isolate just the eyelashes for a stylish and unusual portrait.

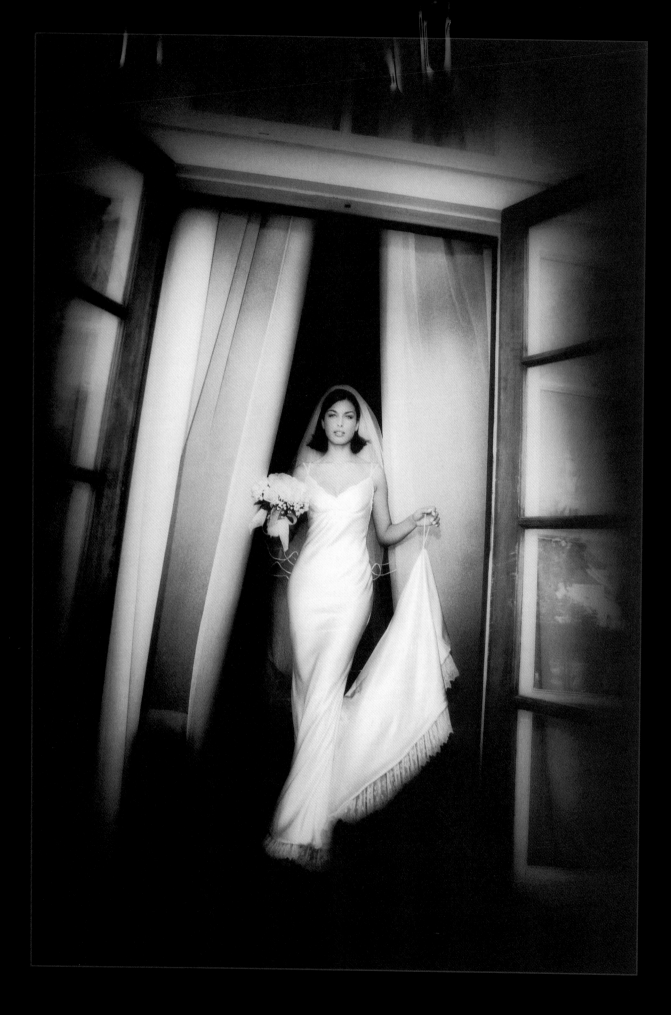

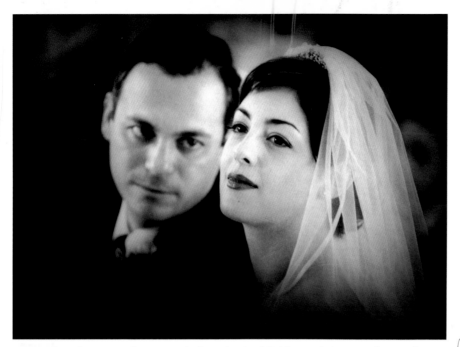

ABOVE—Long lenses produce very shallow depth of field, a technique used to perfection here by Joe Buissink. The "subject" of this portrait is the beautiful bride, who is isolated by the zone of sharp focus that separates her from the groom, who is much softer. Even though slightly soft, the recognition of the groom's admiring look is an important component of this fascinating portrait. FACING PAGE—Wide-angle lenses should be used carefully in order to avoid distortion of the portrait subject. They should be used for an intentional effect. Here Joe Buissink used a wide-angle effectively to reveal the emergence of a gorgeous bride from open balcony doors. The tilted camera enhances the wide-angle effect and the graceful stride of the bride. This image won a Grand Award in the 2002 WPPI print competition.

You can use a much longer lens if you have the working room. A 200mm lens, for instance, is a beautiful portrait lens for 35mm. It provides very shallow depth of field and allows the background to fall completely out of focus, creating a backdrop that won't distract from the subject. When used at wide apertures, this focal length provides a very shallow band of focus that can be used to accentuate just the eyes, for instance, or just the frontal planes of the subject's face. Alternately, it can be used to selectively throw certain regions of the face out of focus.

You should avoid using extreme telephotos (longer than 300mm for 35mm), however, for several reasons. First, perspective may become distorted—the subject's features may appear compressed, depending on the working distance—the nose often appearing pasted to the subject's face, and the ears of the subject appearing to be parallel to the eyes. Secondly, you will have to be a good distance away from the subject with such a lens, making communication next to impossible. You want to be close enough to the subject so that you can converse normally without shouting out posing instructions.

Three-Quarter- and Full-Length Portraits. When making three-quarter- or full-length portraits, it is advisable to use the normal focal-length lens for your camera. This lens will provide normal perspective because the camera-to-subject distance is greater than when making a head-and-shoulders

portrait. The only problem you may encounter is that the subject may not separate visually from the background with the normal lens. It is desirable to have the background slightly out of focus so that the viewer's attention goes to the subject, rather than to the background. The normal lens features a slightly greater depth of field, so this separation may be difficult to achieve even when working at wide lens apertures. This is particularly true when working outdoors, where patches of sunlight or other distracting background elements can easily detract from the subject.

Group Portraits. When making group shots, you are often forced to use a wide-angle lens. Although the background problems noted above can actually be even more pronounced, a wide-angle is often the only way you can fit the group into the shot and still maintain a decent working distance. Be aware when you use wide-angles to make group portraits that the closer the subjects are to the edges of the frame, the more distortion occurs.

● THE PORTRAIT THROUGH THE VIEWFINDER
The only way to be absolutely certain of what the camera is recording is to look through the viewfinder up to and including the moment of exposure. That means not even taking your eye away from the viewfinder to make eye-to-eye contact with your subject.

Ideally, you want the camera to see an undistorted, flattering view of the face and body. Monte Zucker's procedure for adjusting camera height is to first place the camera at the height needed for the amount of the body that is showing. Then he looks through the viewfinder while making final ad-

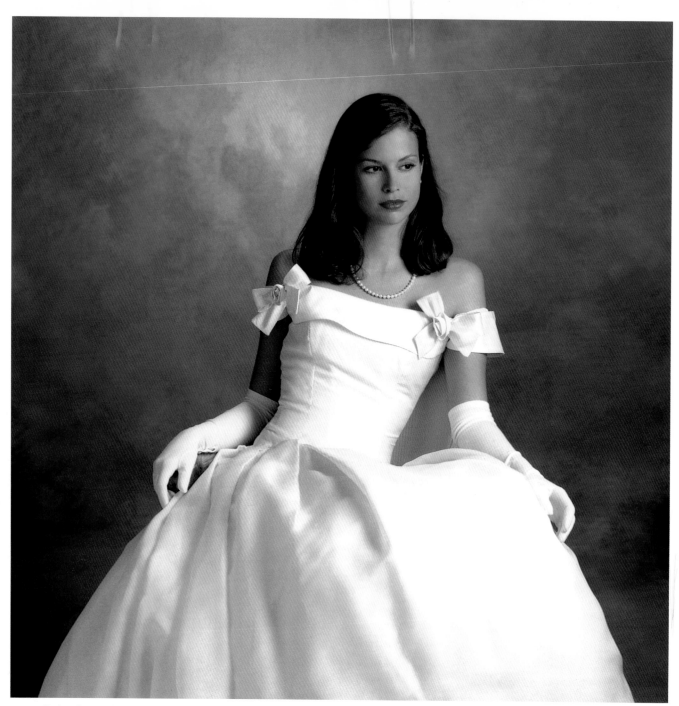

Tim Kelly has learned to pay attention during those lulls in the posing, such as when changing film backs. Here, in an image entitled *The Debutante*, Kelly captured a perfect blend of elegance and indifference as the girl relaxed during a break in the shooting.

justments to his subjects. "I will adjust the subject's face up or down and/or side to side to look its best."

● OBSERVING THE SUBJECT

Tim Kelly is one of America's finest portrait photographers. He observes that, "As you turn your attention to load film, you may glimpse your subject in a totally self-disclosing moment of self-revelation." This illusive expression

has become known around Kelly's studio as the "thirteenth frame"—the one that basically got away. He now pays special attention to the moments during and after film changes or breaks in the shooting. The image of the debutante relaxing (above) was one such "candid" moment. He advises, "Watch your subjects before you capture the image. Sometimes the things they do naturally become great artistic poses." Tim Kelly doesn't direct the

subject into a pose. Rather, he suggests that you get the subject "into the zone" of the pose by coaching their position, but let them go from there. This allows him to capture a more natural feeling.

● FACIAL ANALYSIS

The expert portrait photographer should be able to analyze a subject's face with a brief examination, much like a doctor examines a patient for symptoms. Under flat light, examine the subject from straight on and gradually move to the right to examine one side of the face from an angle, and then repeat on the left side. You can do this while conversing with the person and they will feel less self-conscious. Examine the face on both sides from full face to profile. In your analysis, you are looking for a number things:

1. The most flattering angle from which to photograph the person. It will usually be at the seven-eighths or three-quarters facial view, as opposed to head-on or in profile.

2. A difference in eye size. Most people's eyes are not identical in size. The eyes can be made to look the same size by positioning the smaller eye closest to the lens, so that natural perspective takes over and reduces the size of the larger eye because it is farther from the lens.

3. You will notice the face's shape and character change as you move around and to the side of your subject. Watch the cheekbones become more or less prominent from different angles. High and/or pro-

Often a facial analysis can occur while the photographer is conversing with the subject. The subject will not even realize they are being scrutinized, but such an evaluation will offer keys to camera height and angle, lighting, pose, expression, and even composition. Martin Schembri created this elegant soft-focus portrait.

Robert Cavalli, best known as a master printer, is also an excellent photographer. Here, in an image called *Those Eyes*, Cavalli has isolated just the subject's mysterious eyes to create a compelling and graphically pleasing portrait. The eyes reveal volumes about a person and in this image, a sense of mystery and intelligence is seen.

nounced cheekbones are a flattering feature in both males and females.

4. Look for features to change: a square jaw line may be softened when viewed from one angle; a round face may appear more oval-shaped and flattering from a different angle; a slim face may seem wider and healthier when viewed from head on, and so forth.

5. Examine all aspects of the face in detail and determine the most pleasing angle from which to view the person. Then, through conversation, determine which expression best modifies that angle—a smile, a half-smile, no smile, head up, head down, etc.

The Eyes. The area of primary visual interest in the human face is the eyes. The portrait photographer must live by those words—truly, the eyes are the most expressive part of the face. If the subject is bored or uncomfortable, you will see it in his or her eyes.

The best way to keep the subject's eyes active and alive is to engage the person in conversation. Look at the person while you are setting up and try to find a common frame of interest. Ask your subject about himself—the one subject *everyone* is interested in talking about. If the person does not look at you when you are talking, he or she is either uncomfortable or shy. In either case, you have to work to relax your subject and encourage trust. Try a variety of conversational topics until you find one the person warms to and then pursue it. As you gain your subject's interest, you will take his or her mind off of the portrait session.

The direction the person is looking is important. Start the portrait session by having the person look at you. Using a cable release or wireless remote with the camera tripod mounted forces you to become the host and allows you to physically hold the subject's attention. It is a good idea to shoot a few frames of the person looking directly into the camera, but most people will appreciate some variety. Looking into the lens for too long a time will bore your subject, as there is no personal contact when looking into a machine. Many photographers don't want to stray too far from the viewfinder and so they will just "come up" from the viewfinder to engage the subject just prior to the moment of exposure.

A piece of advice from Monte Zucker regarding the eyes is, "When looking through your lens check to see if your subject's eyes look completely open. Many times I have my subjects actually looking above the lens when I'm creating their portrait, but in the picture it

ground. When in doubt, ask the sitter if the pose *feels* natural; this is usually a good indicator of what *looks* natural.

● HAIRSTYLE AND MAKEUP

There is no doubt that the fine portrait is enhanced with appropriate hairstyling and makeup. For women, jewelry is an important part of the equation, as well. Professional hairstyling and makeup are essential to an elegant portrait, but the stylist, in each case, should be familiar with what works on film. For example, with makeup, a little goes a long way, since the photographic process increases the contrast of a scene.

Monte Zucker favors a conservative approach. He says, "Makeup should be almost imperceptible. I usually suggest that a foundation be applied to a woman's face. It should be blended carefully over the jaw line onto the neck. An abrupt color change between the face and neck should be avoided. Mascara is almost always essential. Even women who feel that they don't usually want makeup should be photographed with at least a minimum of mascara. A gloss lipstick is also important, as is eye shadow that defines the eyes but does not call attention to the color of the eyelids."

Hairstyles are tricky because you do not want to create a dated portrait, and the subject's hairstyle can clearly indicate the era in which a portrait was made—unless one opts for a classical look. Generally, hair in the face and eyes should be avoided.

A consultation is essential when preparing for a portrait session. Bill McIntosh, who does most of his elegant portraits in the home, pays a visit and determines which room

will be used with which props and furnishings. Then he discusses clothing, jewelry, hairstyle and makeup with the subject(s). These things are discussed in detail, so there are no surprises on the day of the sitting.

Duane Sauro is the master of the mysterious portrait. In this image, a senior portrait commissioned as a gift for the subject's mother, the young girl suggested the makeup, props, and hairstyling. Sauro elongated her fingers and toes and added some unusual body parts, like the pointed ears and dragonfly wings, using Photoshop and Painter.

3. Composition

While composition and posing go hand in hand, so to speak, certain elements are unique to posing, and others unique to how the photographer composes the image in the viewfinder. The elements of composition are designed to create visual motion. In other words, the tools of composition exist to coerce the viewer into being visually compelled by the image. Some of these techniques work on a conscious level, some on a background level, but their effect, overall, is to generate heightened visual interest in the portrait.

● THE RULE OF THIRDS

Many photographers don't know where to place the subject within the frame and, as a result, opt to place the person in the center of the picture, which is the most static type of portrait you can produce.

The easiest way to improve your compositions is to use the rule of thirds. Examine the diagram on the facing page. The viewing area is divided into nine separate rectangles by four lines. Where any two lines intersect is an area of dynamic visual interest and an ideal spot to position your main point of interest. Placement of the center of interest anywhere along one of the dividing lines can also create an effective composition.

In head-and-shoulders portraits, for example, the eyes would be the area of central interest. Therefore, it is a good idea if they fall on a dividing line or at an intersection of two lines. In a three-quarter- or full-length portrait, the face is the center of interest. Thus, the face

ABOVE—Gary Fagan's *Portrait of an Artist* uses the rule of thirds grid to define the subject's space and dominance within the portrait. The artist not only dominates the portrait by virtue of his position and placement within the composition, but also because of his brighter tonal values. RIGHT—This is a digitally manipulated version of a portrait made of the late actor Michael Landon by Phillip Charis. The plane of the face is very evenly divided—the eyes and lips both fall on intersecting one-third lines and are very balanced and symmetrical. The portrait obtains its dynamics from the curvature of the asymmetrical planes of the face, and its sense of mystery from the vacant eyes.

LEFT—Rule of thirds. Diagram by Shell Dominica Nigro. BELOW—Gigi Clark created a lyrical portrait with a beautiful sense of rhythm and design. The line of the alto sax can be traced down through all four portraits and is a sweeping elegant diagonal line. But like musical notes on a score, the subjects' hands sharply intersect the diagonal to give it abrupt breaks and stops. There is an almost perfect sense of balance—visual harmony—to this portrait.

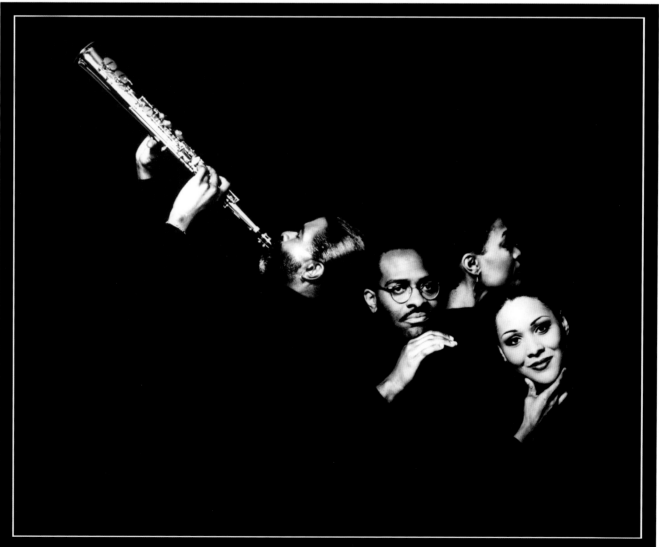

should be positioned to fall on an intersection or on a dividing line.

Usually, the head or eyes are two-thirds from the bottom of the print in a vertical photograph. In a horizontal composition, the eyes or face are usually at the top one-third of the frame—unless the subject is seated or reclining. In that case, they would be at the bottom one-third line.

Regardless of the camera format (square or rectangular), the intersecting grid of the rule of thirds applies. Horizontal or vertical orientation doesn't matter either. While the rule of thirds is just a guide, many photographers have a scribed viewfinder grid that corresponds to the rule of thirds. While they may not use it religiously, it is a constant reminder to offset the subject to create more dynamic compositions.

● DIRECTION
Every good portrait has a sense of direction. This is most easily accomplished by leaving more space in front of the subject than behind

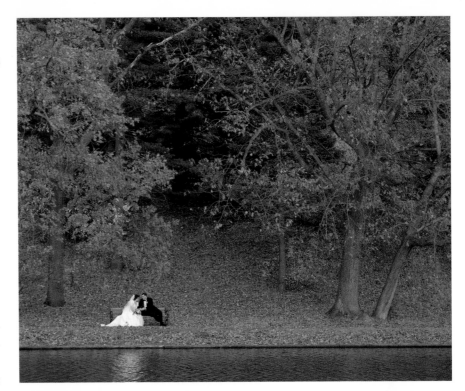

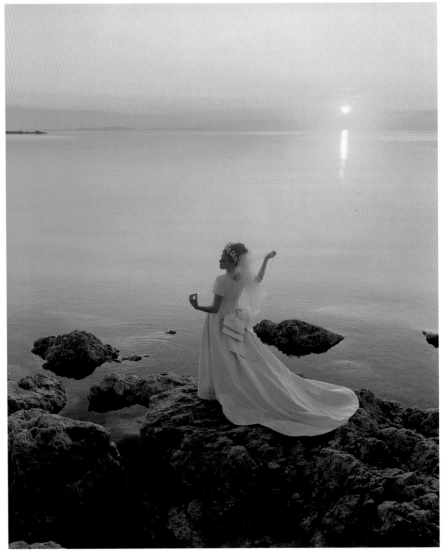

TOP—Don Emmerich's compositions are classically arranged. In this bridal portrait, called *Fallen in Love*, Don arranged the bride and groom in a basic triangle shape that comprises a very small portion of the image. Yet they dominate the image because of their contrast to the uniformity of the autumn background. Note that the positioning of the couple is a variation of the rule of thirds. BOTTOM—Bill Duncan, an art director in a former life, realized that color was not enough to make this portrait dynamic. He chose to give the pose a sense of direction and shape by having the bride arch her back to correspond to the flow of the gown. The result is a delicate curved shape that contrasts the similarity of the horizon line. Note the formal hand posing—Duncan is a master at the posing details.

Deborah Lynn Ferro created this dynamic portrait using two sweeping diagonal lines. From the lower left, the tilt of her subject's head creates the primary diagonal. The line of the subject's left arm leading away from her face creates a secondary diagonal. The portrait has great "stopping power" because of the tight cropping and triangular composition formed by the intersecting diagonal lines. This is an excellent example of visual line and direction.

the subject. Psychologically, this "off-centering" provides a sense of movement and direction. For example, if the subject is looking toward camera right, there should be slightly more space on the right side of the frame (the side to which the subject is looking) than the left side. How much space should be left is a matter of taste and experience. Even if the composition is such that you want to position the person very close to the center of the frame, there should still be slightly more space on the side toward which the subject is turned.

● LINE

Real Lines. To effectively master the fundamentals of composition, the photographer must be able to recognize real and implied lines within the photograph. A real line is one that is obvious—a horizon, for example. Real lines should not intersect the photograph in halves.

This actually splits the composition into separate pictures. It is better to locate real lines at a point one-third into the photograph, thus providing visual "weight" to the image.

Implied Lines. An implied line is one that is not as obvious, like the curve of the wrist or the bend of an arm. Implied lines, such as those of the arms and legs of the subject, should not contradict the direction or emphasis of the composition, but should modify it. These lines should add gentle changes in direction and lead to the main point of interest—either the eyes or the face.

All lines, either real or implied, that meet the edge of the photo-

graph should lead the eye into the scene, not out of it. They should lead toward the main center of interest.

Diagonal Lines. It should be noted that the use of lines is one of the main tools a photographer has in giving a photograph a sense of dynamics. Remember that horizontal and vertical lines are basically static by nature and mimicked by the horizontal and vertical edges of the print. A diagonal line is one that provides a gently sloping path for the viewer's eye to follow. If you examine the work of great photographers you will often see diagonal lines working effectively to enhance the composition.

● SHAPE

Shapes are basic geometric forms, made up of implied or real lines, within a composition. For example, a classic way of posing three people is in a triangle or pyramid shape. You might also remember that the foundation of any well composed portrait is the triangular base.

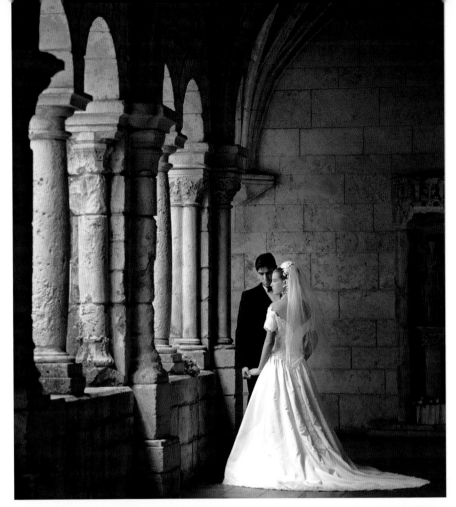

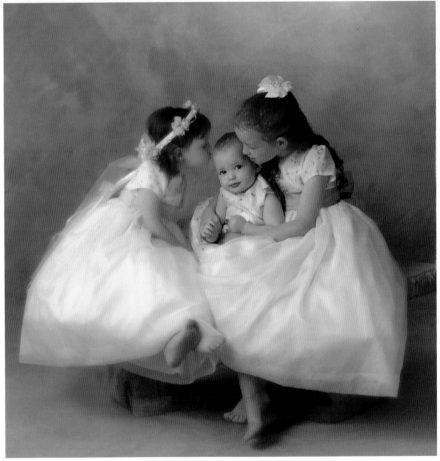

TOP—Rick Ferro is not only a master at classical posing but a first-rate designer. In this image, the only non-straight lines in the image are provided by the curved lines of the overhead buttress and the matching curved line of the bride's gown, which seem to meet in an elegant C shape. Everything else, including the print border is a horizontal or vertical line. It is this type of dynamic that creates an award-winning portrait. BOTTOM—The primary shape in this wonderful portrait is the triangle, but the real emotional dynamics of the portrait come from the two sisters being turned towards the baby. The viewer's eye cannot leave the smaller triangle created by the three heads—the eye bounces back and forth between the sisters, always stopping at the face of the angelic baby. Portrait by Tim Kelly.

Shapes, while more dominant than lines, can be used similarly in unifying and balancing a composition. Sometimes shapes may also be linked by creating a common element between multiple groups. For example, two groups of three people in pyramid shapes can be linked by a person in between—a common technique in posing groups of five or morepeople.

There are an infinite number of possibilities involving shapes, linked shapes, and even implied shapes, but the point of this discussion is to be aware that shapes and lines are prevalent in well composed images and that they are a vital tool in creating strong visual interest within a portrait.

• TENSION AND BALANCE

Just as real and implied lines and real and implied shapes are vital parts of an effectively designed image, so are the "rules" that govern them—the concepts of tension and balance.

Tension occurs when there is a state of imbalance in an image. A big sky and a small subject, for example, creates visual tension. Balance occurs when two items, which may be dissimilar in shape, create a harmony in the photograph because they are of more or less equal visual strength.

Although tension does not have to be resolved in an image, it works together with the concept of balance so that in any given image there are elements that produce visual tension and elements that produce visual balance. This is a vital combination of artistic elements because it creates a sense of heightened visual interest.

Tension can also be referred to as visual contrast. For example, a group of four children on one side

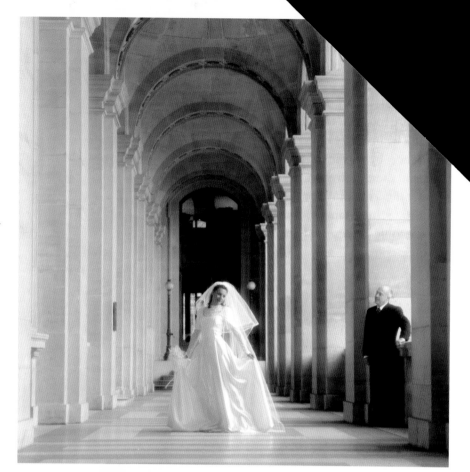

TOP—This portrait by Jerry D has a number of compelling visual elements—the repeating shapes of the arches, the perfectly aligned vertical and horizontal lines of the stone columns, and the elegant pose of the bride, who in a classic arched pose is revealing the details of her elegant wedding dress. The father, off to the side and looking intently at his daughter, is a secondary center of interest that vies for your attention as you visually dissect the image. BOTTOM—Balance and tension are what this image is all about, compositionally. The boy, by color and contrast, dominates the portrait, but notice how the smaller windows to the right equally offset the larger one to the left—a state of perfect balance. Don Emmerich titled this image *Major League Dreamer*.

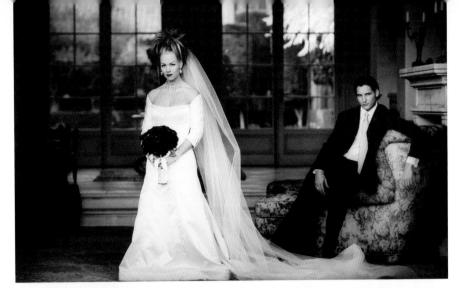

the
...duce
...each
...rent
...milar
...graph
...visu-
...falls
...or for
...tance,
...e two
groups could beally if
the children, the larger group, are
wearing bright clothes and the
pony is dark colored. The eye then
sees the two units as equal—one
demanding attention by virtue of
size, the other gaining attention by
virtue of brightness.

● PLEASING COMPOSITIONAL FORMS
Shapes in compositions provide
visual motion. The viewer's eye fol-
lows the curves and angles as it trav-
els logically through the shape, and
consequently, through the photo-

TOP—This formal wedding portrait by Joe
Buissink is a study in tension and balance.
The image is composed with three main
compositional elements: the bride, the
groom, and the background. The bride is a
primary point of interest because of sub-
ject tone, but she is perfectly balanced
against the form of the groom, who is
angled at a diagonal—a shape that the
eye seeks out. The background, including
the hot spot of the trees on the right side,
balances the dominant shapes of the fore-
ground so that the viewer's eye is constant-
ly moving from one main area to the next.
The secondary dominance of the back-
ground also enhances the illusion of depth
in this image. This is an award-winning
image. BOTTOM—This image by Kevin
Kubota utilizes a flowing S curve in the
composition, created by the veil blowing in
a breeze that was created by a studio fan.
The image is vignetted so that the viewer's
attention is focused on Haddie's radiance
and the elegant form of the image.

graph. The recognition and creation of found and contrived compositional forms is another of the photographer's tools in creating a dynamic portrait.

The S-shaped composition is perhaps the most pleasing of all compositions. The center of interest will usually fall in one of the dynamic quadrants of the image (one of the intersections of the rule-of-thirds grid [see page 39]), but the remainder of the composition forms a gently sloping S shape that leads the viewer's eye to the area of main interest.

Another pleasing type of composition is the L shape or inverted-L shape. This occurs when the subject's form resembles the letter L or an inverted letter L. This type of composition is ideal for reclining or seated subjects. The C and Z shapes are also seen in all types of portraiture, and both are visually pleasing.

The classic pyramid shape is one of the most basic in all art, and is dynamic because of its use of diagonals with a strong horizontal base. The straight road receding into the distance is a good example of a found pyramid shape.

Subject shapes can be contrasted or modified with additional shapes found either in the background or foreground of the image. The "lead-in line," for example, is like a visual arrow that directs the viewer's attention toward the subject.

● SUBJECT TONE

Generally speaking, the eye is drawn to the lightest part of a photograph. The rule of thumb is that light tones advance visually, while dark tones retreat. Therefore, elements in the picture that are lighter in tone than the subject will be distracting. For this reason, bright areas—particularly at the edges of

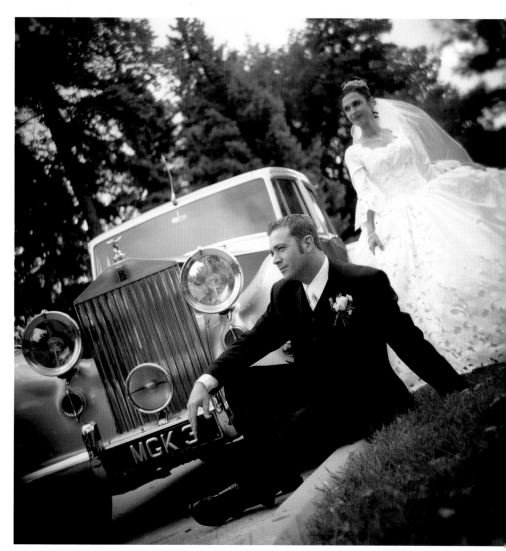

Canadian photographer Vladimir Bekker created this beautiful L-shaped composition, which he made even more dynamic by tilting the camera, a very popular technique. The bride is much more dominant than any other element in the scene because of the brightness of her dress. Bekker subdued the corners in printing to focus attention on the bride.

the photograph—should be darkened either in printing, in the computer, or in the camera so that they do not draw the viewer's eye away from the subject.

Whether an area is in focus or out of focus has a lot to do with the amount of visual emphasis it will receive. For instance, imagine a subject framed in green foliage with part of the sky visible in the scene. The eye would ordinarily go to the sky first. If the sky is soft and out of focus, however, the eye will revert back to the area of greatest contrast—hopefully the face. The same is true of foreground areas.

Although it is a good idea to make this darker than your subject, sometimes you can't. If the foreground is out of focus, however, it will detract less from a sharp subject.

Regardless of whether the subject is light or dark, it should dominate the rest of the photograph either by brightness or by contrast.

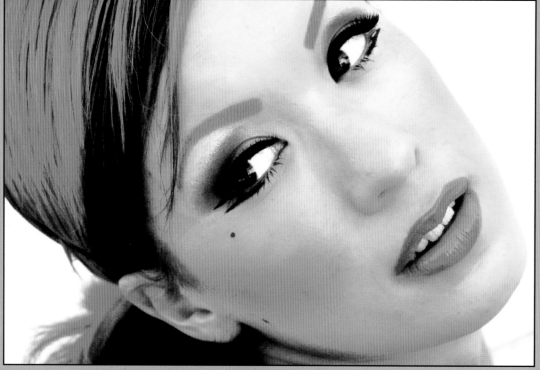

ABOVE—Bambi Cantrell imposed dynamic elements onto this lovely portrait by tilting the camera, introducing the weathered wooden frame, and adding the transparent zig-zag shapes. The result is an image you can't stop looking at. LEFT—In another Bambi Cantrell image, the powerful diagonals of the tilted head and the line of the eyes create a strong composition. The skin tone, hair color, and eye makeup have been altered in Photoshop.

FACING PAGE—This portrait by Martin Schembri has been made dramatic by removing the texture and tone from the girl's hat and sweater, giving the image an infrared look. The effect of the black below and above her face creates a unique tension within the image.

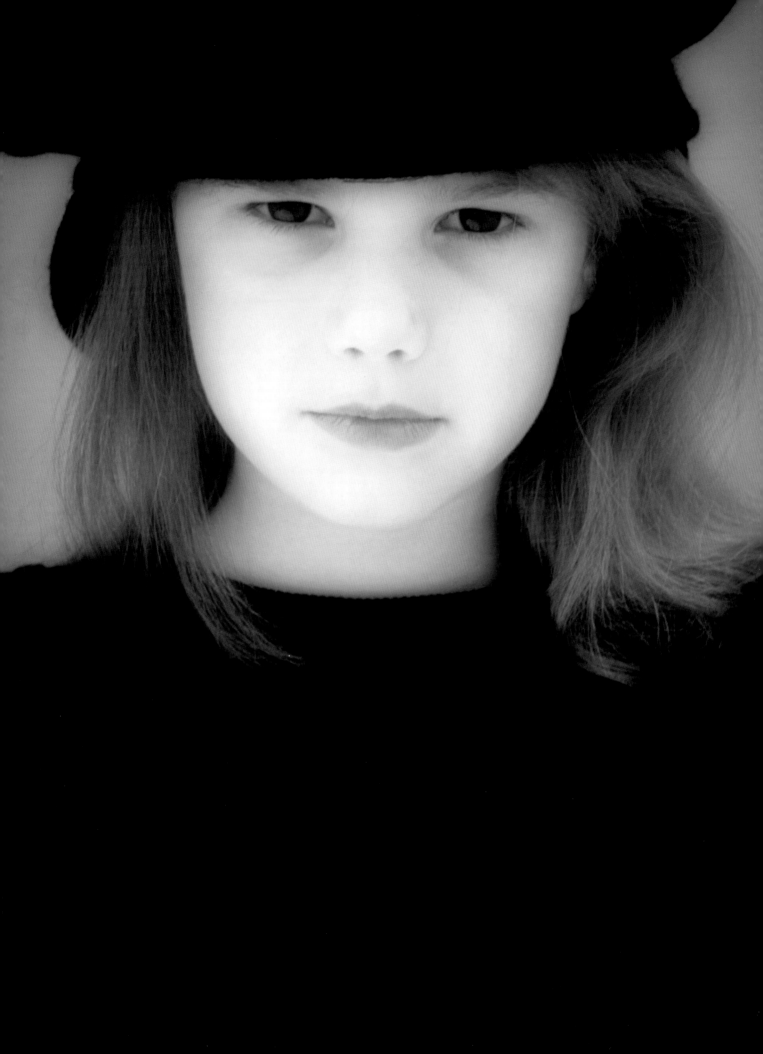

4. Expression

*T*here is no doubt that the subject's expression is a main ingredient in a successful portrait. Of course, the expression doesn't mean only a "winning smile." The portrait itself, in its entirety, is an expression—and often of much more than surface characteristics. At its highest levels, it can be an expression of moral and intellectual character. This ability to convey so many intangible aspects of a person is what fascinates people about portraiture and what has elevated portraiture to the level of art form. The portrait is a work of art that is meant to be contemplated with all the powers of the viewer's imagination.

In today's vernacular, however, the portrait is also a commercial entity. To be accepted and purchased at great fees, it must flatter and invigorate the sitter. There is the belief among fine portrait photographers that the expression elicited by the sitter must not be of a mood or anything temporary. As photographer Phillip Charis characterizes it, "The expression—the most important ingredient—must be tranquil, allowing the viewer to see into the subject's mind." This is accomplished, in part, by the direction of the gaze of the subject. In Charis's portraits the gaze is directly out at the viewer, allowing us a direct connection with the person portrayed.

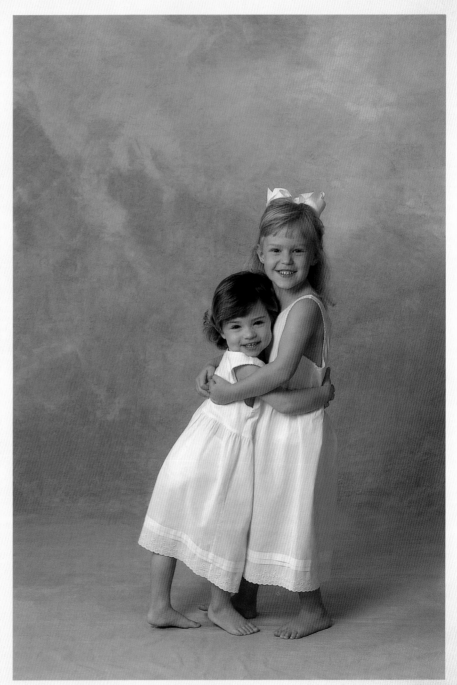

In this memorable Tim Kelly portrait, the photographer remembered that the two little girls posed themselves in a hug, gleefully informing him, "This is how we want to be!" That is exactly how he posed them, and is also the title he gave the award-winning print.

● ELICITING EXPRESSIONS

Another great portrait photographer, Tim Kelly, does not believe in prompting the sitter for expressions, preferring instead to catch his subjects "by gentle surprise." Kelly says, "I don't always warn my clients I am ready to start the session. I don't believe in faking the spontaneity of the subject's expression." He encourages his photography students to watch the subject before capturing an image and be aware that the things they sometimes do naturally make great artistic poses. In fact, Kelly calls his style of portraiture, "the captured moment"—an almost photojournalistic slant to posed portraiture.

Monte Zucker believes that the expression is "the most lasting part of every portrait." Like many photographers, Monte believes the smile is the most endearing expression a human being can make, but he recognizes that many people don't look good smiling. In these situations he'll request a more contemplative, serious expression or ask for "a slight suggestion of a smile" rather than a complete smile—especially if it appears to be a forced smile. Most portrait photographers will agree that there is nothing worse than an artificial smile. Some patrons will have a preference and may want to be photographed in a serious pose.

● SMILE FORMULA

Monte has a "smile formula," if you will. He always asks his subjects to show him the whole row of upper teeth when they're smiling, saying that, "Anything less than that usually looks artificial." He often suggests that subjects "smile with their eyes," which gets them to forget about their mouths for the most natural expression. Of course,

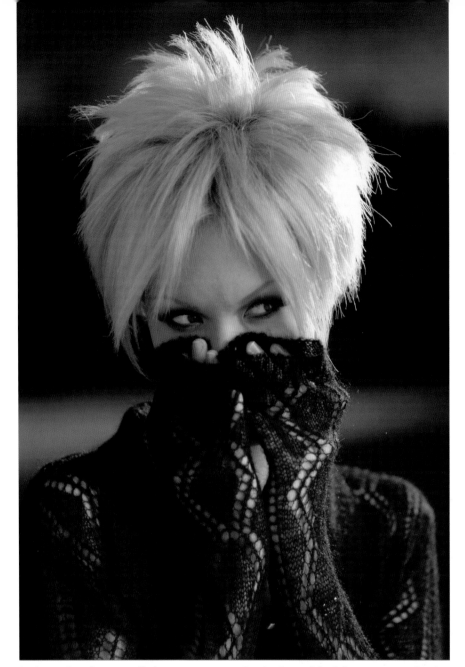

In the midst of a controlled portrait session, Bambi Cantrell had the inspiration for this portrait. She somehow coaxed her model into the pose, which is both charming and unforgettable. Bambi uses this image on her web site.

Monte is capable of making anyone smile.

Bill McIntosh also subscribes to the "smiling eyes" concept and often invokes the smile with a barrage of outrageous flattery or cornball humor. Since Bill photographs many wealthy women as clients, and is from the South (Virginia), it is important that his female clients look "charming." McIntosh weaves a web of interaction through conversation and good rapport and

tries to establish a rhythm and flow so he can record the subject reacting to the give-and-take conversation. He says, "When you photograph someone, you are, with your voice and body language, putting your subject in a light stage of hypnosis. You make exposures surreptitiously and do your best to take their mind off the fact that they are being photographed."

Gallery of Images

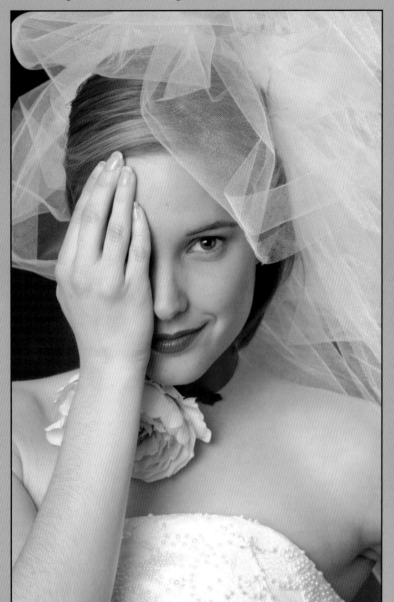

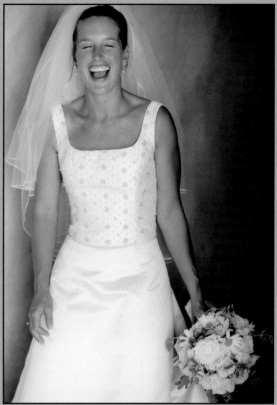

ABOVE—The idea of a bridal portrait with the bride covering one eye, as if she were the victim of a practical joke, is in itself laughable. For Gigi Clark, who will try anything to get a great portrait, it's just another technique to elicit a beautiful and timeless expression. TOP RIGHT—Becker is a gregarious, likeable wedding photographer who joins into each event as if he were the honored guest. He literally lights up a room with his good-natured humor. Here, he has succeeded in totally cracking up his bride. Net result: a memorable image. BOT-TOM RIGHT—The kids in a wedding party make great subjects that can fill a wedding album with chuckles. Here again, Becker, has managed to capture this terrific portrait, complete with cowlick, on wedding day. Photo made by available light.

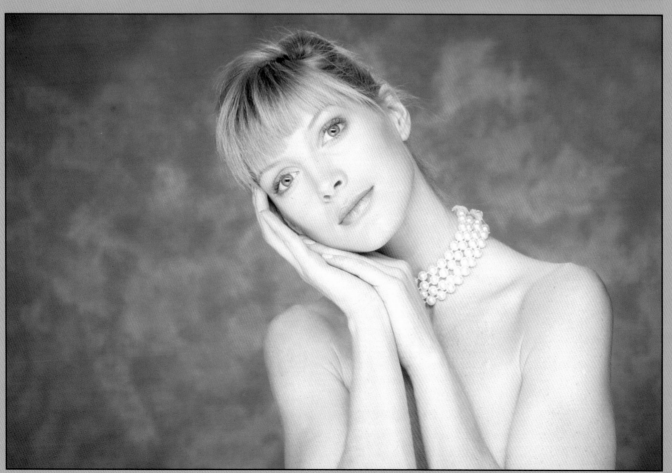

RIGHT—Tim Kelly is a master at eliciting expressions from his subjects. Here, he managed to get a perfectly natural "anti-smile" from his subject. Notice how relaxed the pose is and how the open piano lid creates a triangle that points right to his subject. BELOW—Don Emmerich created this wonderful portrait entitled *Irresistible* using fashion lighting (very diffused lighting on the same axis as the subject and lens) and classic hand posing that seems to outline the subject's beautiful face.

Bill McIntosh often photographs regal and very wealthy subjects. It is crucial that the expression match the stature of the individual. A broad smile would not have been appropriate for the "Duke."

LEFT—Rick Pahl does a lot of senior portraits. He will often photograph teenage girls in fashion mode, as was done here. The expression that he elicits is very grown up and sexy, which was the object of the exercise. The subject loved it. ABOVE—Australian Malcolm Mathieson is a gifted wedding photographer but he is a true photojournalist in the sense that he doesn't like to set things up or create "faked" emotion. Here, he has captured a timeless expression at the wedding of Matthew and Rochelle, an event which got moved from its original venue to the pub on the day of the wedding so the couple could be with their "mates."

Retouching is expected in a fine portrait and when a customer sees unretouched proofs, they will normally recognize that certain aspects of their appearance "need a little work."

Bill McIntosh has an interesting practice. "My subjects are mostly middle aged or older and need some softening under their eyes, and some work on the lines around their mouths and necks. Sometimes they need their jowls thinned down and their waist line also trimmed a little. Therefore, when the previews arrive, I have two choices. I can select the best one or two poses and have them retouched and custom printed in the 8" x 10" size. Or, if the portrait can be used as a sample for one of my ongoing exhibits, I will print a portrait of the size I believe would fit a wall in her house (which I have already viewed), frame it and take it to her home for a viewing with the other previews."

The retouching that is done today differs greatly from that done only a few years ago. In comparing traditional retouching with today's digital retouching, master photographer Frank Frost states, "The difference is like night and day. We can digitally retouch an entire order in the time it used to take us to retouch just a couple of negatives."

In the case of Phillip Charis's fine portraits, once the final portrait is custom printed, it is returned to the studio for expert retouching and enhancing in order to remove "unfortunate details" and idealize the very form of the subject. Once mounted, the print is then lacquered to give it a rich, "softly luminescent" surface. Then it is framed in a custom-made, gold-leaf frame, and furnished with a picture lamp if desired.

Retouching Then. Traditional retouching involved the use of a large- or medium-format negative and a highly skilled retoucher who would apply lead and/or retouching dye to the negative. The idea behind retouching is to blend the uneven densities of the negative for a smoother, more polished look. By building up tone in the slightly less dense areas, the skin becomes cleaner and more uniform; in short, it comes closer to the ideal.

The leads were held in holders and were interchangeable. 2H, 4H, and 6H are the designations for hard leads; HB and 2B are designations for the softer leads; each lead having a specific purpose and and function for retouching specific areas on the negative. The retoucher worked on a retouching stand with a brightly backlit panel. The negative was mounted above the light and a powerful magnifying glass on a gooseneck stand was used to enlarge the area of the negative for the retoucher.

Before retouching could begin the negative was often "doped"—meaning that retouching medium was applied to give the negative "tooth," or a surface receptive to accepting leads and dyes. With leads sharpened to perfection (this was done by sliding the pencil into a folded piece of fine sandpaper and then twirling the pencil so that it became rounded as well as extremely sharp), the retoucher began blending areas of the negative using the leads to build up density. Starting out with the retouching pencils on the emulsion side of the negative, the retoucher usually started with the 4H lead for average retouching. The softer leads were then used for deeper shadow areas. The lead had to be constantly resharpened to a fine point.

Lines were softened, blemishes removed, smile lines and deep furrows minimized, catchlights repaired, age spots removed, and all the myriad of items covered by the retoucher were handled in turn. It was a painstaking and time-consuming skill that required years of training to do well. One of the constant problems for a retoucher was when a negative refused to accept any more lead. It would then have to be flipped and more lead applied to the other side of the negative. To make matters worse, the techniques involved for lead retouching are somewhat different than those for dyes, which involve using an almost dry brush to apply very thin applications in very small areas.

Other tools used by the conventional retoucher were the abrading tool (a needle used to remove pinholes and other completely opaque spots on the negative), the etching knife (used to "shave" density in microscopic dimensions from the negative—to repair "blown out" highlights, for example) and the spotting brushes and dyes (which were used to retouch the print from over-retouching or dust spots produced in enlargement.

Retouching Now. The fact that most photographers moved away from the large-format negative towards the medium- and small-format negative—and now to digital—has all but put a halt to conventional retouching. Retouching is now done to the digital file and the image is conveniently worked as a positive (rather than a negative), so that what you see is what you get. Retouching a scanned or native digital image in software applications like Adobe Photoshop is much easier and less time consuming than the traditional retouching methods. The retouched digital image file can

either be output directly to an inkjet media or photographic paper, or rewritten to negative film (with the use of a film recorder) so that traditional prints can be made on photographic enlarging paper.

Retouching a digital image in Photoshop allows you to enlarge any portion of the image up to 1600 percent, so that virtually any detail in the image can be reworked. A wide variety of brushes and pencils and eraser brushes can be selected and the opacity and transparency of each tool is easily adjusted in minute increments. Photoshop also allows you to select an area you want to retouch and apply any changes *only* to that area. Photoshop 7.0 also has amazing tools—the Healing Brush, for example, allows you to clone an adjacent area of the image, complete with lighting angles and textures, and use the data to "heal" a nearby problem area. For instance, the lines under a person's eyes can be eliminated by sampling a smooth area under the lines and then applying the smooth area to the wrinkled one. Blemishes are so simply removed that it's almost laughable when compared to the work that went into that operation in the conventional retoucher's studio.

Not only can facial irregularities be eliminated digitally, but drastic retouching tasks—like swapping the head from one pose and repositioning it on another—are a matter of routine. You simply select, copy, and paste. There is almost no end to the complex effects that can be produced digitally.

 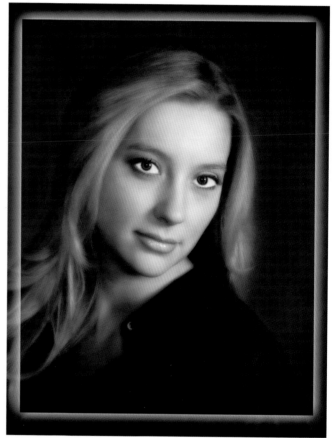

The original photograph (left) was taken at a WPPI MasterClass workshop at WPPI 2003 by the instructor, Gary Fagan. The original image was made with a Canon D-60 and 85mm EOS lens, using a 3:1 lighting ratio created with Photogenic Powerlights with an Eclipse umbrella fill and a 20-inch soft box as the main light. The image was then brought into Adobe® Photoshop®, cropped, converted to grayscale mode and then to RGB mode. It was then carefully retouched using the Clone tool, which works by selecting a benign area of the image and then applying that information to the area you want to conceal. For example, to remove a blemish, one would select from a clear area of skin and then clone it over the blemish. Fagan also used the Liquify tool to enhance the left eye, which was drooping slightly (in Liquify, he just nudged the eyelid up a little). The Gaussian Blur was used to create the soft focus effect. This was achieved by creating a duplicate layer in the layers palette, enabling the Gaussian Blur, and then erasing the diffusion effect using the eraser tool with an opacity setting of 35. By erasing the areas of the image you want sharp, the diffusion remains in those areas you want soft, but you can reintroduce sharpness in the areas of the portrait that need to be sharp—the eyes, the hair, the lips, etc. Gary then created a new layer in which he imposed an outer glow and border, creating a three-dimensional frame for the portrait.

5. Lighting

The basic function of portrait lighting is to illuminate the subject and to create the illusion of three-dimensional form in a two-dimensional medium. While lighting has an aesthetic function, helping to idealize the subject or creating a romantic or sentimental mood, the functional aspects of portrait lighting are to show roundness and contouring in the human face and form. Good lighting also reveals the textural qualities of skin. Lighting should create a balanced sense of realism and idealism, and a heightened sense of dimension and depth.

In traditional portraiture, there are five basic lighting patterns that are used repeatedly. These five lighting patterns (and countless variations on them) are established methods of lighting the human form. They all stem from the notion that, as in nature, all light should emanate from a single source like the sun.

While these lighting patterns are most obvious when using the undiffused light from parabolic reflectors, most portrait photographers don't light this way anymore. Instead, they opt for diffused light sources—larger light sources—that provide a blanket of soft, flattering light on their subjects. Still, the basic lighting patterns are the same and their relevance, although somewhat diluted these days, is still sig-

nificant because they offer clearly defined ways for creating the illusion of three-dimensional lighting in a two-dimensional medium.

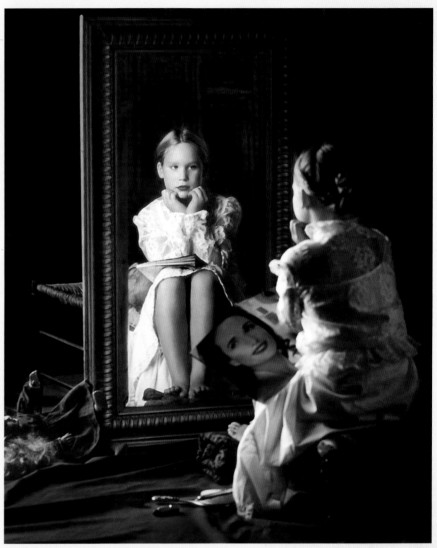

Tammy Loya calls this image *A Rockwell Moment*, because "Norman Rockwell has been a big influence in my work. I wanted my portraits to have a real life feeling and he captured that in his images. I've always loved the image of the girl in the mirror—you know what she's thinking. I had to have the correct camera angle for lighting her, so I wouldn't show up in the mirror. I seated her and metered her reflection, and the rest is history. It was all done with natural light from my 6' x 6' north light window." Tammy exposed the image for one second at f/8, with the camera's reflex mirror up, using a cable release. Image was made on a Mamiya RZ 67 and 180mm lens.

● LIGHTS AND MODIFIERS

All five lighting patterns are based on the use of four different lights: the key or main light; the fill light,

TOP—Stephen Dantzig created this elegantly lit portrait using soft light sources in close to his subject. The lighting pattern created is a modified loop pattern, as you can see from the diffused shadow under her nose. Fill is via reflector—the light basically wraps around the contours of her face. BOTTOM—Jerry D created this beautiful portrait using butterfly lighting with no fill. The light was positioned high and above the subject and only the fill from the studio opened up her eye sockets. The lighting is dramatic and glamorous. A background light illuminates the painted backdrop.

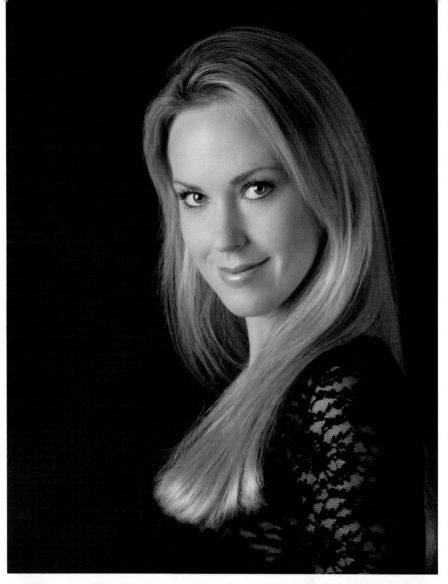

which "fills in" the shadows created by the key light; the hair light, and the background light. Optional lights, such as additional backlights, or kickers as they're sometimes called, are also frequently used.

When these lights are used in parabolic reflectors, barn doors should be affixed to the reflectors. These help control stray light and are used to widen or narrow the beam of light from the lamp head.

If these lights are used in diffusers, such as softboxes, umbrellas, or other light-softening devices, barn doors cannot be used and therefore the lights must be "feathered," so that the edge and not the core of light is being used.

● THE FIVE BASIC
PORTRAIT LIGHTING SETUPS

Paramount Lighting. Paramount lighting, sometimes called butterfly lighting or glamour lighting, is traditionally a feminine lighting pattern that produces a symmetrical, butterfly-like shadow beneath the subject's nose. It emphasizes high cheekbones and good skin. It is generally not used on men because it tends to hollow out cheeks and eye sockets too much.

The key light is placed high and directly in front of the subject's

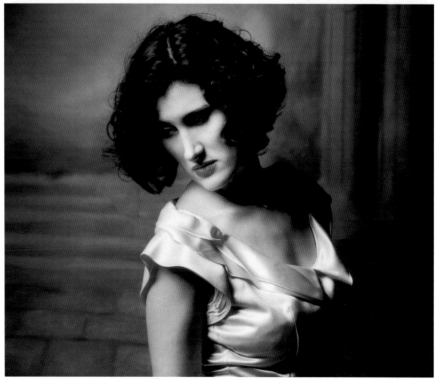

face, parallel to the vertical line of the subject's nose (see diagrams, facing page). Since the light must be high and close to the subject to produce the desired butterfly shadow, it should not be used on subjects with deep eye sockets, or no light will illuminate the eyes.

The fill light is placed at the subject's head height directly under the key light. Since the key and fill lights are on the same side of the camera, a reflector should be used on the opposite side from the lights and close to the subject to fill in the deep shadows on the neck and cheek.

The hair light, which is always used opposite from the key light, should light the hair only and not skim onto the face of the subject.

The background light, used low and behind the subject, should form a semi-circle of illumination on the background (if using one) so that the tone of the background grows gradually darker the farther out from the subject you look.

Loop Lighting. Loop lighting is a minor variation of paramount lighting. The key light is lowered and moved more to the side of the subject so that the shadow under the nose becomes a small loop on

the shadow side of the face. This is one of the more commonly used portrait lighting setups and is ideal for people with average, oval-shaped faces.

In loop lighting, the fill light is moved on the opposite side of the camera from the key light. It is on the camera/subject axis. It is important that the fill light not cast shadows of its own in order to maintain the one-light character of the portrait. The only place you can

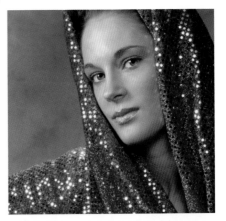

RIGHT—Monte Zucker created an elegant portrait using the loop lighting pattern. Diffused lighting softens the shadows. The eyes were retouched in Photoshop so that the fill light's reflection was retouched out, preserving the one-light look. Note that the catchlights are positioned at 11:00 on the surface of the eye—1:00 or 11:00 is the preferred position for catchlights. BELOW—Australian photographer Martin Schembri photographed his subject with window light that created a modified loop lighting pattern. There is a substantial fill-in source from the shadow side of the face, creating a low lighting ratio of 2:1, which is accentuated by the very contrasty warehouse background.

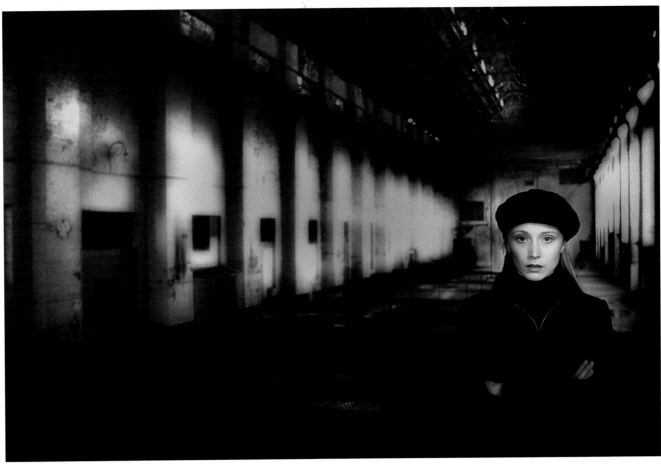

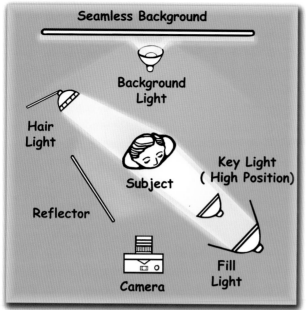

Paramount Lighting

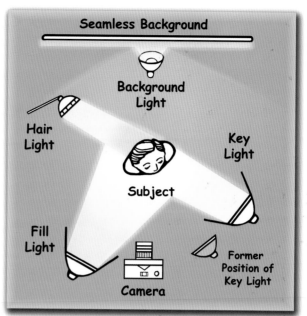

Loop Lighting

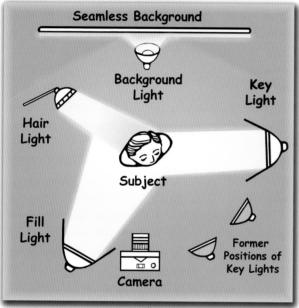

Rembrandt Lighting

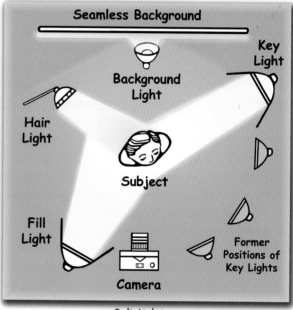

Split Lighting

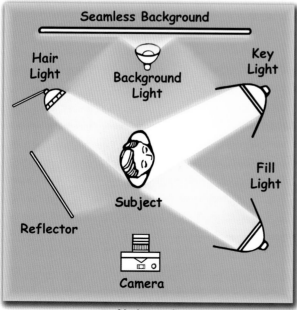

Profile/Rim Lighting

These diagrams show the five basic portrait lighting setups. The only real difference between them is the placement of the key light. Lighting patterns change as the key light is moved from close to and high above the subject to the side of the subject and lower than head height. The key light should not go below eye level, as lighting from beneath does not occur in nature. You will notice that when the key and fill lights are on the same side of the camera, a reflector is used on the opposite side of the subject to fill in the shadows. Diagrams by Shell Dominica Nigro.

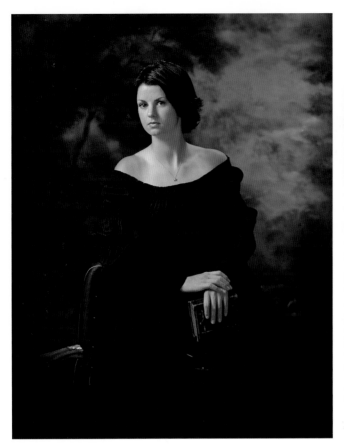

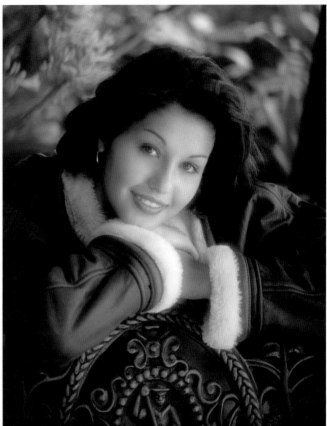

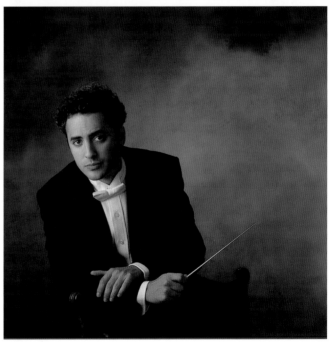

TOP LEFT—In this Phillip Charis portrait you can see the lighting patterns at work. This image is between a loop pattern and a Rembrandt pattern. Charis used soft light so that the pattern is diffused, but minimal fill so that there would be good contouring and depth. The lighting pattern is short lighting (you can see more of the shadow side of the face than the highlighted side) and there is good feathering of the main light (there is excellent highlight detail and less light on the hands, caused by feathering the main light away from the subject). TOP RIGHT—The softer the lighting, the less discernable the lighting pattern. This is an outdoor portrait by senior photographer Jeff Smith. Although there is excellent roundness and contouring, the lighting pattern is not visible. Jeff used a gobo to block light from above, causing it to come in from the side, creating a beautiful outdoor portrait light. He also diffused the image on camera. RIGHT—This is a very dramatic portrait created by Tim Kelly. A Rembrandt lighting pattern is visible and a very strong lighting ratio of at least 4:1 was employed. The posing of the hands is expert and the creation of a sharp dynamic line with the baton is a stroke of genius.

really observe if the fill light is effective is at the camera position. Judge to see if the fill light is casting a shadow of its own by looking through the viewfinder.

The hair light and background light are used the same way they are in paramount lighting.

Rembrandt Lighting. Rembrandt or 45-degree lighting is characterized by a small, triangular highlight on the shadowed cheek of the subject. The lighting takes its name from the famous Dutch painter who used a window to illuminate his subjects. This type of

lighting is often thought of as dramatic, and is more typically a masculine style. It is commonly used with a weak fill light to accentuate the shadow-side highlight.

The key light is moved lower and farther to the side than in loop and paramount lighting. In fact, the

key light almost comes from the subject's side, depending on how far the head is turned away from the camera.

The fill light is used in the same manner as it is for loop lighting. The hair light, however, is often used a little closer to the subject for more brilliant highlights in the hair. The background light is in the standard position.

With Rembrandt lighting, additional backlights, called kickers, are often used to delineate the sides of the face and to add brilliant highlights to the temples and shoulders. When setting such lights, you must be careful not to allow them to shine directly into the lens of the camera, because this will cause image-degrading flare. The best way to check is to stand at the camera position with the frontal lights extinguished. Then, place your hand between the camera and the backlight to see if it casts a shadow on the lens. If so, then the kicker is shining directly into the lens and should be adjusted.

Split Lighting. Split lighting is when the key light illuminates only half the face. It is an ideal slimming light that can be used to narrow a wide face or nose. It can also be used with a weak fill light to hide facial irregularities, or with no fill light for highly dramatic effect.

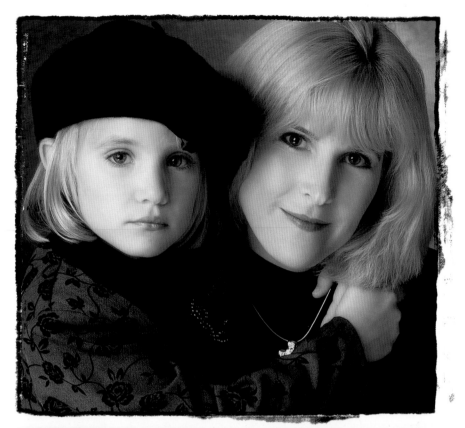

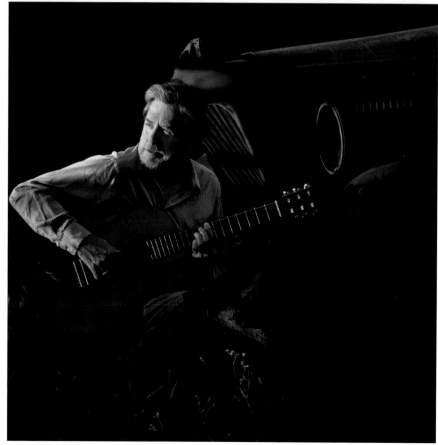

TOP—In this elegant portrait, Tim Kelly employed split lighting to fully light one half of each face. Because the light source is so soft and because the main light is used farther forward than in true split lighting, the light wraps around on the shadow sides of the faces. Here's a tip—you can read the position of the main light by looking at the location of the catchlight in the eyes. In this image, the catchlights are at 9:00 o'clock. BOTTOM—Split lighting is dramatic. Here, Heidi Mauracher used the last rays of direct sunlight to create a split light on this outdoor subject. No fill-in caused only the highlights—bleached red and yellow by the setting sun—to be prominent. Two diagonal lines intersect the portrait, giving it a wonderful sense of tension and balance.

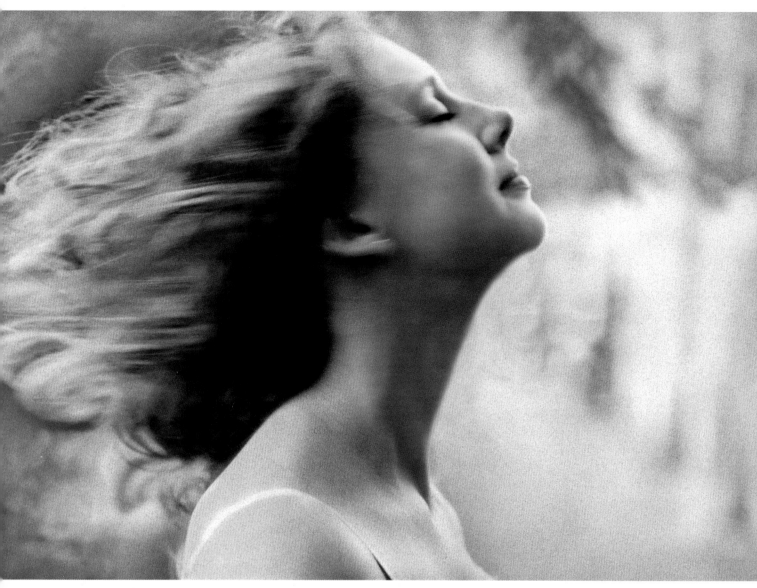

This is a fabulous portrait by Elaine Hughes. It is full of emotion and exposes the woman's graceful neck. Elaine employed outdoor lighting, soft and overhead, and had the bride tilt her head up toward the light so that highlights would fall on the frontal planes of the face. A thin rim of a highlight exists around the profile of her face, but not her neck; the light being blocked by her chin prevents the neck from getting direct light.

In split lighting, the key light is moved farther to the side of the subject and lower (see diagram, page 59). Sometimes, the key light is slightly behind the subject, depending on how far the subject is turned from the camera. The fill light, hair light and background light are used normally.

Profile Lighting. Profile or rim lighting is used when the subject's head is turned 90 degrees from the camera lens. It is a dramatic style of lighting used to accent elegant features. It is used less frequently now than in the past, but it is still a stylish portrait lighting.

In rim lighting, the key light is placed behind the subject so that it illuminates the profile, leaving a highlight along the edge of the face and highlighting the hair and neck of the subject. Care should be taken so that the accent of the light is centered on the face and not so much on the hair or neck.

The fill light is moved to the same side of the camera as the key light (like it is in loop lighting), and a reflector is used to fill in the shadows (see diagram, page 59). An optional hair light can be used on the opposite side of the key light for better separation of the hair from the background. The background light is used normally.

As you progress through the lighting setups from paramount to

RIGHT—In an elegant and very symmetrically composed profile, Mercury Megaloudis utilized the properties of directional open shade to create a memorable profile. With no fill on the camera side of the subject, the diffused daylight wraps around the bride, contouring the frontal planes of her face and rim lighting the transparent veil. BELOW—Here is a beautiful variation on profile lighting. Instead of moving the light behind the subject, David Williams positioned it almost directly in front of his subject. The light falls off as it strikes the frontal planes of his face and hand, creating contouring and showing excellent dimension. Williams' sense of balance is superb—notice how he used the music stand in the background to provide a trio of forms for the viewer's eye to react to.

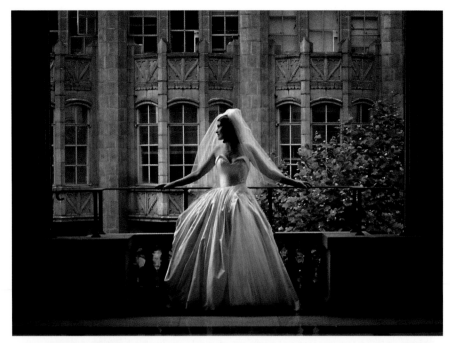

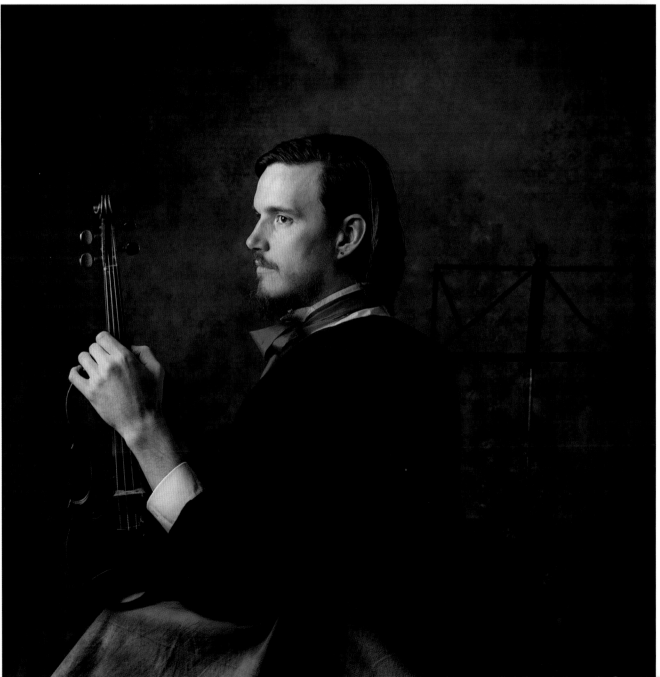

RIGHT—Don Emmerich created this fashion portrait by positioning the main light (a softbox) over the lens and a reflector beneath the lens to produce soft light that washes the features of the subject. Makeup helps in the contouring of the planes of the face. FACING PAGE—Steve Dantzig created this fashion portrait using very soft light—a large 3' x 6' softbox positioned close to the model. He used no fill, but instead, optimized the light quality of the softbox by positioning it close to the model at a distance of about 50" and feathering the light until the best roundness and highlight detail were visible from the camera position. Steven also softened select areas of the image in Photoshop to create a view-camera effect. Only the mask of her face is sharp.

split lighting, each progressively makes the face slimmer. Each also progressively brings out more texture in the face because the light is more to one side, thus revealing surface texture.

As you progress from paramount to split, the key light mimics a setting sun—at first high, and then gradually lower—in relation to the subject. It is important that the key light never dip below subject/head height. In traditional portraiture this does not occur, primarily because it does not occur in nature.

● FASHION LIGHTING

Fashion lighting is a variation of conventional portrait lighting. It is extremely soft and frontal in nature—usually on the lens/subject axis. Fashion lighting does not model the face, leaving that job primarily to the subject's makeup. It is a stark lighting that is usually accomplished with a large softbox directly over the camera and a silver reflector just beneath the camera. Both the light and reflector are very close to the subject for the softest effect. When you examine the

catchlights in a fashion portrait you will see two—a larger one over the pupil and a less intense one under the pupil. Sometimes, you may even see a circular catchlight produced by a ring-light flash—a type of light that mounts around the lens for completely shadowless lighting.

Fashion lighting is often used in senior photography, especially for girls, or for a makeover that involves professional hairstyling and a makeup artist.

When it comes to male fashion portraiture the current style is a bold, dramatic, masculine look. Flat-lighting is seldom used with

men. Side-lighting with hard shadows seems to work well.

● FEATHERING THE LIGHTS

Lights must be set with sensitivity. If you merely aim the light directly at the subject, you will probably "overlight" the subject, producing pasty highlights with no detail.

You must adjust the lights carefully, and then observe the effects from the camera position. Instead of aiming the light so that the core of light strikes the subject, feather the light so that you employ the edge of the light to illuminate your subject. The trick is to add brilliance to your highlights. The high-

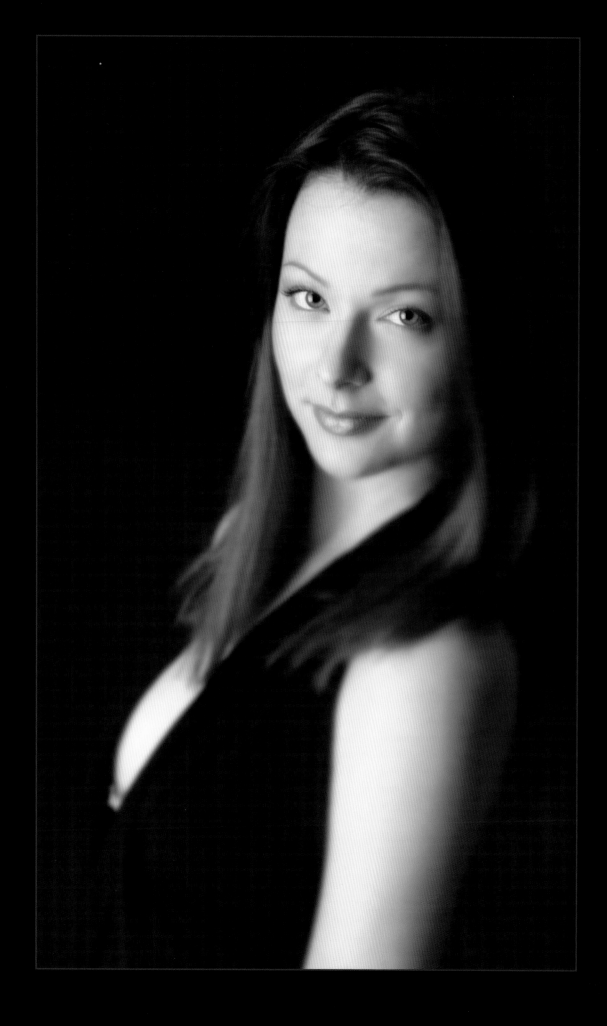

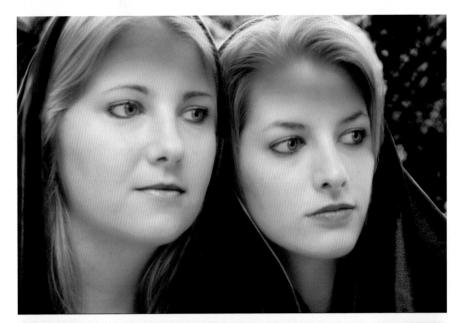

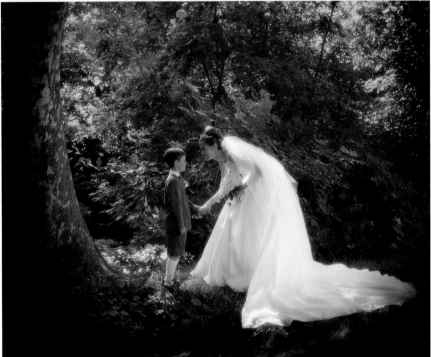

TOP—This Rick Pahl portrait, entitled *Sisters*, is a good example of what can be done with lighting in Photoshop after the image has been taken. In Rick's words, "We put shadowing on the girl, camera left, to thin her a little. Then we put makeup and cloned the eyes from her sister. When all was done, there seemed to be just too much forehead on both girls, so we added a shadow that could belong to a tree branch across their foreheads." While this image *was* made outdoors, the lighting patterns (loop on the left, butterfly on the right) were added in Photoshop. BOTTOM—This is a good example of perfect profile lighting found in nature. A wooded glen allows sunlight to filter in and edge-light the subjects. The photographer, Ferdinand Neubauer, used flash near the camera to open up the shadow side of the subjects. So its effect would not be overly obvious, he had the flash fire at an output two stops less than the ambient light exposure. FACING PAGE—David Williams is a master of recreating a bygone era with modern materials. This image is from his Masterworks series, originally created for Eastman Kodak, Australia. It is a good example of short lighting, in which the shadow side of the face is more prominent.

lights, when brilliant, have minute specular (pure white) highlights within the main highlight. This further enhances the illusion of great depth in a portrait.

Feathering is one way of adjusting the light for added highlight brilliance. However, since you are using the edge of the light, you will sometimes cause the level of light to drop off appreciably with no noticeable increase in highlight brilliance. In these cases, it is better to make a slight lateral adjustment of the light in one direction or another. Then check the result in the viewfinder.

It should be noted that whether you are using raw or diffused light, use of the feathered edge of the light is recommended.

● FILL LIGHT PROBLEMS

The fill light can pose its own set of problems. If too close to the subject, the fill light produces its own set of specular highlights that show up in the shadow area of the face and make the skin appear excessively oily. If this is the case, move the camera and light back slightly, or move the fill light laterally away from the camera slightly. You might also try feathering the light in toward the camera a bit. This method of limiting the fill light is preferable to closing down the barn doors of the light to lower the intensity of the fill light.

Another problem that the fill light often creates is multiple catchlights in the subject's eyes. These are small specular highlights that appear on the iris of the eye. When you use a fill light you will get a set of catchlights from the fill as well as the primary set from the key light. There is really no way around the effect. The second set of catchlights is usually removed in retouching.

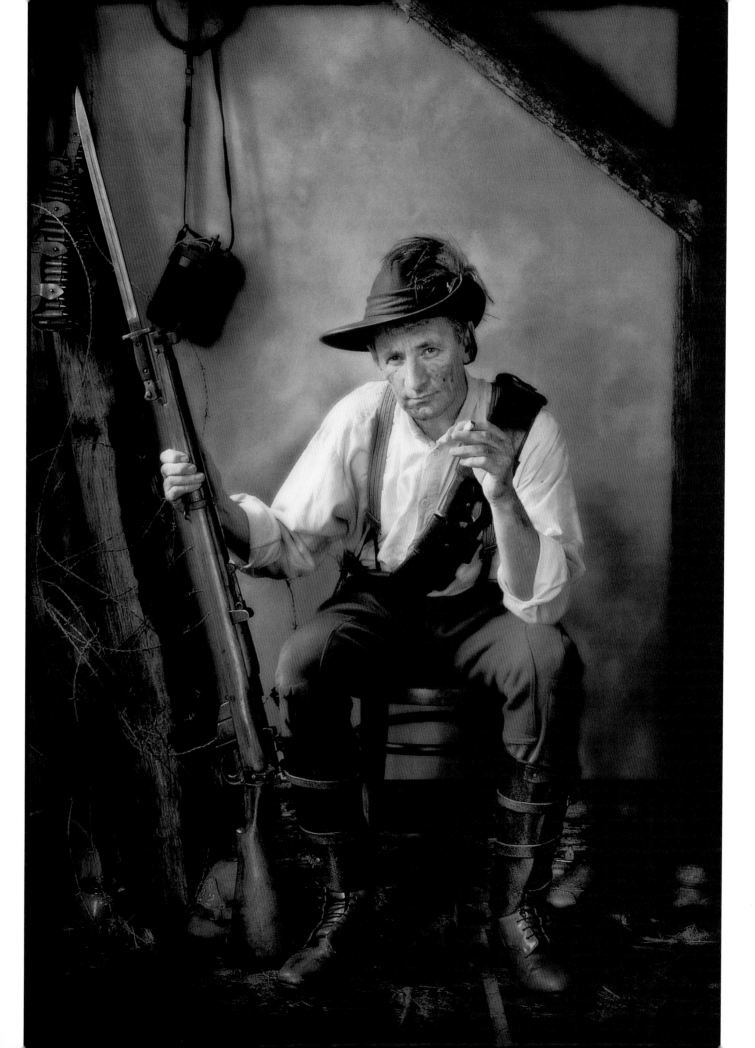

● BROAD AND SHORT LIGHTING

We have talked about the five basic lighting patterns and the four basic lights, but there are also two basic types of portrait lighting, broad and short lighting. Broad lighting means that the key light is illuminating the side of the face turned toward the camera (the side of the face that is widest from the camera's perspective). Broad lighting is used less frequently than short lighting because it tends to flatten out and de-emphasize facial contours, minimizing form. It can, however, be used to widen a thin or long face. Broad lighting places three-quarters of the face in highlight. A low-contrast, large main-light source works best for this type of lighting. Broad lighting is normally used with high-key lighting setups.

Short lighting means that the key light is illuminating the side of the face turned away from the camera (the side of the face that is narrowest from the camera's perspective). Short lighting emphasizes facial contours, and can be used as a corrective lighting technique to narrow a round or wide face. When used with a weak fill light, short lighting produces a dramatic lighting with bold highlights and deep shadows. Short lighting is by far the more prominent of the two types of lighting and is used most often for average-shaped faces.

● LIGHTING RATIOS

The term "lighting ratio" is used to describe the difference in light intensity between the shadow and highlight sides of the face. Ratios are expressed numerically—3:1, for example, means that the highlight side of the face is three times brighter than the shadow side.

Ratios are useful because they reveal how much overall contrast

there will be in the portrait. They do not determine *scene* contrast (the clothing, background and tone of the face determine that), but rather how much lighting contrast will be present on the subject. Ratios also determine how much the light will slim the face of the subject. The higher the lighting ratio (the greater the tonal difference between the highlight and shadow side of the face), the thinner the subject's face will appear.

RIGHT—A low lighting ratio, such as seen in this precious image by David Bentley, has little difference between the highlight and shadow sides of the face. However, a good portrait must always show contouring in the planes of the face as this image does. The image was made in studio on a set the Bentleys use to simulate high-key window light. BELOW—Rita Loy created this beautiful bridal portrait with a very functional 3:1 lighting ratio. Daylight was the main light source, but a reflector was positioned to camera right in order to fill in the shadows on the bride. All of the room lights were turned on to add to the light level and create a warm tone.

Since lighting ratios tell the difference in intensity between the fill light and the key light, the ratio is also an indication of how much shadow detail will be in the final portrait. Since the fill light controls the degree to which the shadows are illuminated, it is important to keep the lighting ratio fairly constant. A desirable ratio for color film is 3:1 because of the rather limited tonal latitude of color printing papers. Black & white films can

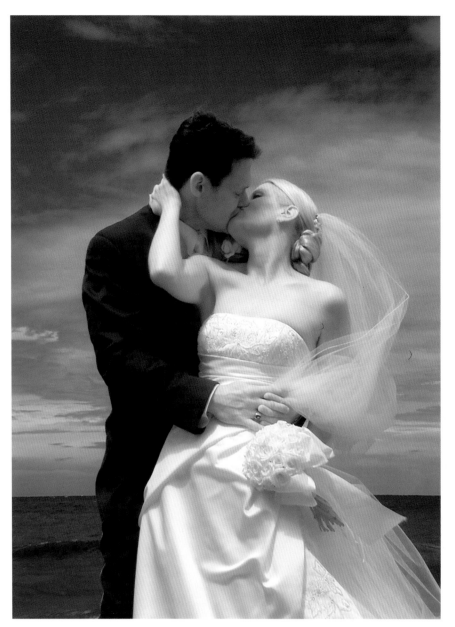

ABOVE—Norman Phillips created this low-key (4:1 lighting ratio) image in the studio by positioning the main light nearly behind the subject. The light was an umbrella, so the quality of the light is soft and wraps around the frontal planes of her face. A kicker was used to add sheen to the hair on the camera side of the subject. The hair on the right side of the image was lit by the umbrella and edge-lighted. RIGHT—Images taken in sunlight ordinarily have a high lighting and scene contrast. Here, Patrick Rice had high cloud cover, which diffused the sunlight a bit. He helped matters by firing a diffused Metz flash into the scene to further lower the contrast and lighting ratios. The image was made digitally, emulating black & white infrared effects.

stand a greater ratio—up to 8:1—although, when the ratio is this high, it takes a near perfect exposure to hold detail in both highlights and shadows.

Determining Lighting Ratios. To determine the lighting ratio, measure the intensity of the fill light on both sides of the face with an incident light meter, then measure the intensity of the key-light side of the face. If the fill light is next to the camera, it will cast one unit of light on each side (shadow and highlight sides) of the face. The key light, however, only illuminates the highlight side of the face, not the shadows it creates. If the key light is the same intensity as the fill light, then you will have a 2:1 lighting ratio—one unit of light on each side of the face from the fill light, and one unit of light on the highlight side of the face only from the key light. This means that the light on the highlight side of the face is twice as bright as on the shadow side; thus a 2:1 ratio.

How Lighting Ratios Differ. A 2:1 ratio shows minimal roundness in the face and is most desirable for high key effects. High key portraits are those with low lighting ratios, light tones, and usually a white background.

A 3:1 lighting ratio is produced when the key light is one stop greater in intensity than the fill light. (One unit of light on both sides of the face from the fill light plus two units of light on the highlight side from the key light equals a 3:1 ratio.) This ratio is the most preferred for color and black & white because it will yield an exposure with excellent shadow and highlight detail, reveals good roundness in the face and is ideal for rendering average faces.

TOP—Snow often creates the ultimate high-key lighting. Here, Dennis Orchard used the bright and shadowless light of nearby snow on the ground to create a nearly 1:1 lighting ratio outdoors. It is very difficult to even find a shadow in this scene. Dennis knew that all he had to do was to photograph the woman on the porch, get a good expression, and the light would do the rest. BOTTOM—Norman Phillips created this low-key portrait with his main light to the left of his subject, almost behind her. He used no fill and let the shadows fall where they would, creating a strong 4:1 lighting ratio. No background light was used, but a hair light was employed to add detail to the subject's dark hair. FACING PAGE—Tammy Loya's studio consists of a large 6' x 6' north-light window that she uses as a main light. The light quality is normally very soft and she often doesn't even need to use a fill source for beautiful portraits. In this case, however, she used a reflector on the shadow side of the little girl to help lower the lighting ratio.

A 4:1 ratio is used when a slimming or dramatic effect is desired. In a 4:1 ratio, the shadow side of the face loses its slight glow and the accent of the portrait becomes the highlights.

Ratios of 4:1 and higher are typical of low key portraits, which are characterized by dark tones and a dark background. A 5:1 ratio and beyond is considered a high-contrast rendition. It is ideal for conveying a dramatic effect and is often used in character studies. Shadow detail is minimal or nonexistent at the higher ratios and as a result, they are not recommended for color films unless your only concern is highlight detail.

You may, of course, have fractional lighting ratios, such as 3.5:1. This particular ratio is created when the key light is between one and two stops greater than the fill light.

● LIGHT MODIFIERS

Spotlights. A spotlight is a hard-edged light source. Usually it is a small light with a Fresnel grid lens attached. The Fresnel lens is a glass filter that focuses the spotlight, making the beam of light stay condensed over a longer distance. Barn doors are usually affixed to

spots so that they don't spray light all over the set. Spots are often used to light a selective area of the scene, like a corner of the room or a portion of a seamless background. They are usually set to an output less than the main light or fill. Hard-light sources like spots produce a more defined shadow edge, giving more shape to the subject's features than low-contrast, diffused light sources.

Parabolic Reflectors. A parabolic is a polished silver metal reflector into which the lamp or strobe head is placed. It produces a sharp light with well defined shadows and lots of contrast. In the old days, everything was lit with parabolics because of the light intensity needed to capture an image on very slow film. This was obviously before strobes. The advantage of learning to light with parabolics is that you had to see and control light more efficiently than with diffused light

sources, which are infinitely more forgiving.

Parabolics create a light pattern that is brighter in the center (called the umbra) with light gradually falling off in intensity toward the edges (called the penumbra). The umbra is hot and unforgiving and produces highlights without detail on the face. The penumbra—the soft edge of the circular light pattern—is therefore the area of primary concern to the portrait photographer. By feathering the light (adjusting the light so as to use the soft-edged penumbra) you can achieve even illumination across the facial plane with soft specular highlights. Using barn doors or diffusers on the main light minimizes the soft-edge effects, but sometimes barn doors are neccessary to control stray light on the set.

Diffusers. Unlike the main light, the fill light should be equipped with a diffuser, which is nothing more than a piece of frosted plastic or acetate in a screen that mounts to the perimeter of the reflector. Using a diffuser turns a parabolic-equipped light into a flood light with a broader, more diffused light pattern. When using a diffuser over a light, make sure there is sufficient room between the diffuser and the reflector to allow heat to escape. The fill light should also have barn doors attached.

If using a diffused light source, such as an umbrella, for a fill light, be sure that you are not spilling light into unwanted areas of the scene, such as the background. As with all lights, diffused lights can be feathered by aiming the core of light away from the subject and just using the edge of the beam of light.

Barn Doors. These are black, metallic, adjustable flaps that can be opened or closed to control the

Richard Pahl created this senior portrait using a large softbox placed close to the subject. The lighting pattern is so soft that Pahl decided to use Adobe® Photoshop® to define some shadow areas and create a sense of three-dimensional form. He also created a line of specular highlights along the bridge of her nose.

width of the beam of the key light. Barn doors ensure that you light only the parts of the scene you want lit. They also keep stray light, which can cause lens flare, off the camera lens.

Umbrellas and Softboxes. Photographic umbrellas are either white or silver, and are used fairly close to the subject to produce a soft, directional light. A silver-lined umbrella produces a more specular, direct light than does a matte white umbrella. When using lights of equal intensity, a silver-lined umbrella can be used as a main light because of its increased intensity and directness. It will also produce

specular highlights in the overall highlight areas of the face. A matte-white umbrella can then be used as a fill, or secondary light.

To use an umbrella most effectively, the light should be focused into the umbrella. Sliding the lamp head up and down the shaft with the modeling light on will show you the amount of light that escapes and is directed past the umbrella. When the beam of light is as wide as the perimeter of the opened umbrella, it is focused effectively.

Some photographers use the umbrella in the reverse position, turning the light and umbrella around so that the light shines through the umbrella and onto the subject. This gives a softer, more directional light than when the light is turned away from the subject and aimed into the umbrella.

Of course, with a silver-lined umbrella, you can't shine the light through it because the material is almost fully opaque. There are many varieties of shoot-through umbrellas available commercially and they act very much like softboxes.

Softboxes are another type of light modifier and produce light that is highly diffused—and may even be double diffused with the addition of a second scrim over the lighting surface. Some softbox units also accept multiple strobe heads for additional lighting power and intensity.

While these light sources are ultra soft, it is still usually necessary to fill in the shadow side of faces to prevent the shadow areas from going dead. Further, because umbrellas and softboxes produce a broad beam of light, the light scatters, often eliminating the need for a background light (this is also subject to how far the background is from the light source, however; the farther it is from the light, the darker it will record).

Both umbrellas and softboxes may be interchanged as key or fill light sources, and even as hairlights and backlights when used in strip-light configurations (small, but long softboxes). In using umbrellas and softboxes, it should be noted that the closer the light is to the subject, the softer the quality of the light. As the light is moved farther back, the sharper and less diffused the light becomes.

Reflectors. Reflectors are any large white, silver, or gold surface that is used to bounce light into the shadow areas of a subject. A wide variety are available commercially, including the kind that are collapsible and store in a small pouch. The silver and gold foil surfaces provide

Outdoor lighting can be every bit as soft as diffused studio light. In this image entitled *Girl Next Door*, Don Emmerich has utilized soft directional daylight as a key light. A gold-foil reflector adds warmth to both sides of the face and lowers the lighting ratio to almost 2:1. The light quality is so soft that the lighting pattern is barely perceptible.

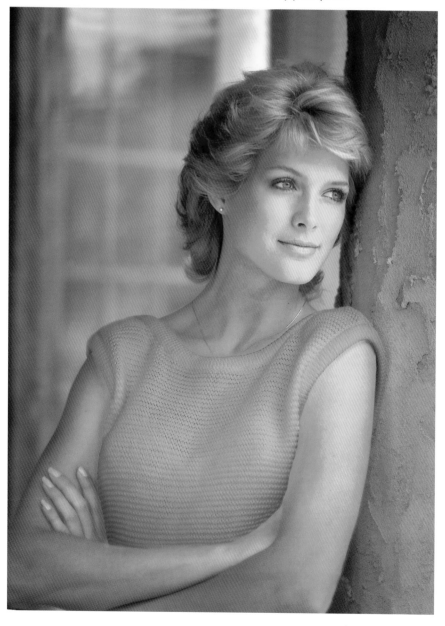

more light than white surfaces, and the gold reflectors are ideal for shade, where a warm tone in the fill light is desirable.

When using a reflector it should be placed slightly in front of the subject's face. Be careful not to position it beside the face, where it may resemble a secondary light source coming from the opposite direction as the main light. This is counterproductive.

Properly placed, the reflector picks up some of the main light and wraps it around onto the shadow side of the face, opening up detail even in even the deepest shadows.

Gobos. Gobos, or "black flags" as they're sometimes called, are lightweight opaque panels that are used as light blockers. In the studio, they are used to shield a part of the subject from light. In the field, they are often used to block overhead

light when no natural obstruction exists. This reduces the overhead quality of the lighting and minimizes the creation of shadows under the eyes. In effect, the gobo lowers the angle of the main light source so that it is more of a sidelight. Gobos are also used to create a shadow when the source of the main light is too large, with no natural obstruction to one side or the other of the subject.

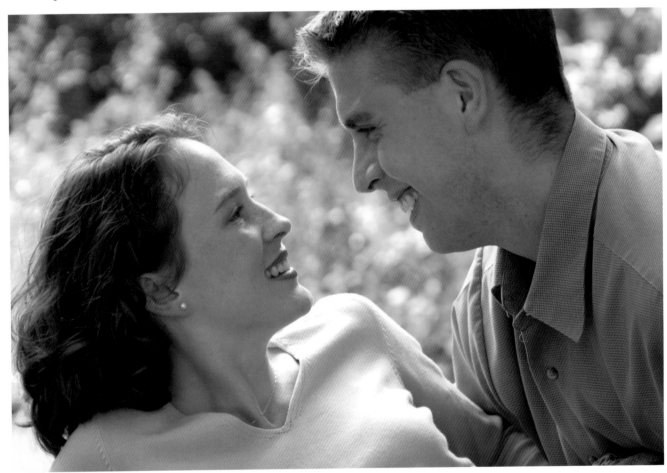

ABOVE—Monte Zucker teaches his students how to harness sunlight for elegant portrait lighting. In this image, Monte used a scrim held above the couple to diffuse the direct sunlight, creating a subtle backlighting. Ordinarily, a fill-in reflector would be used to fill the frontal shadows, but in this case, none was required. LEFT—Here is how the reflector was positioned above the couple. Note that the background, a combination of sunlight and shade, is about one to two stops brighter than the exposure on the couple, which is reduced due to the diffusion characteristics of the translucent light panel.

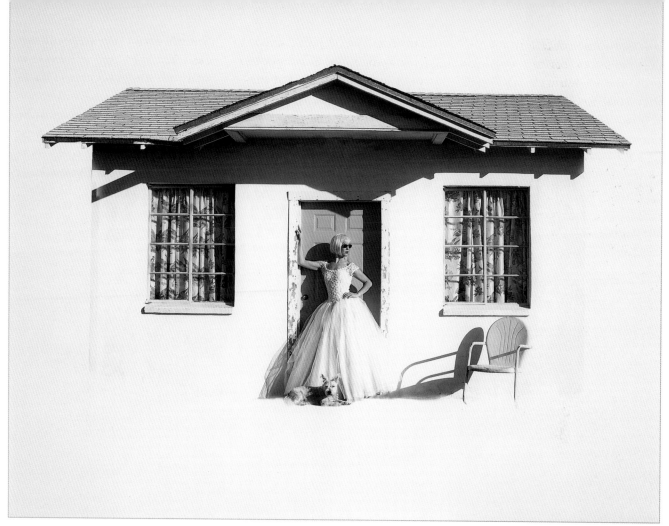

ABOVE—Direct sunlight is not a good choice for a main light in portraiture. Here, Heidi Mauracher used it effectively and eliminated the problem of the bride squinting by outfitting her in sunglasses. Heidi eliminated the background and foreground completely in Photoshop to make this a really unusual image. RIGHT—The late afternoon sky can sometimes act like a huge softbox, creating shadowless light with a frontal direction. Such is the case here in an engagement portrait made by Joe Photo. Joe also used a telephoto lens, which reduced the overall scene contrast slightly.

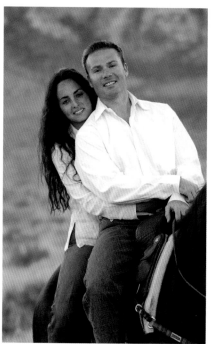

Scrims. Scrims are a means of diffusing light. In the movie business, huge scrims are suspended like sails on adjustable flats or frames and positioned between the sun (or a bank of lights) and the actors, diffusing the light on the entire area. A scrim works the same way as a diffuser in a softbox works, softening the light that shines through it.

Monte Zucker has perfected a system of using large scrims—3' x 6' and bigger. With the sun as a backlight, he has several assistants hold the translucent light panel above the subject so that the back-lighting is instantly diffused. He then places a reflector close in front of the subject to bounce the diffused backlight onto the face. The effect is very much like an oversized softbox used close to the subject for heavily diffused, almost shadowless light.

Scrims can also be used in window frames to soften sunlight that enters the windows. The scrim can be tucked inside the window frame and is invisible from the camera position.

From the following descriptions of four basic studio lighting setups, you will see how completely different they are—ranging from Phillip Charis's almost simplistic setup, to Monte Zucker's practice of simultaneously using two separate strobe systems.

Phillip Charis. Phillips Charis's studio is relatively simple with one Norman strobe and a 42" umbrella for a key light, and another Norman with a white umbrella for fill. These are augmented with a softbox hair light, and a spotlight used occasionally on backgrounds (usu-

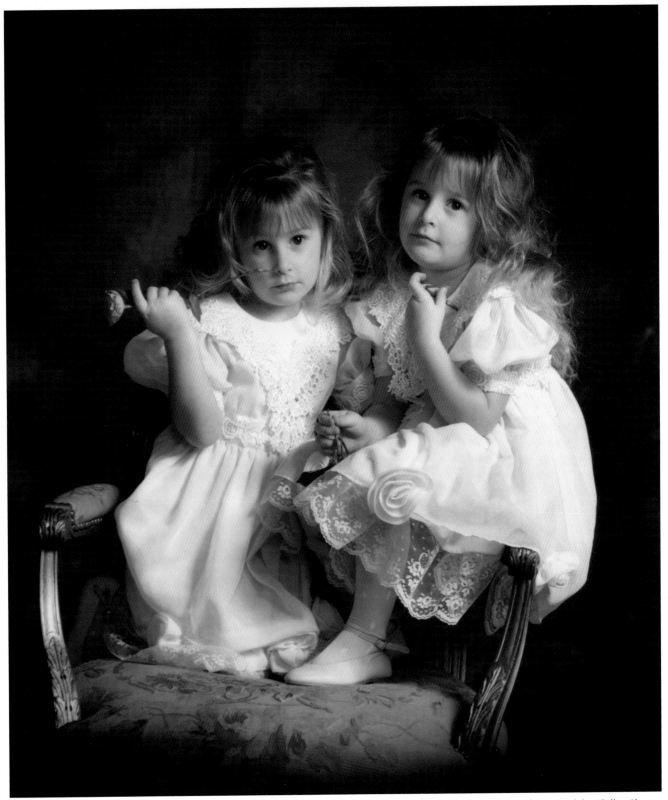

Photograph by Phillip Charis.

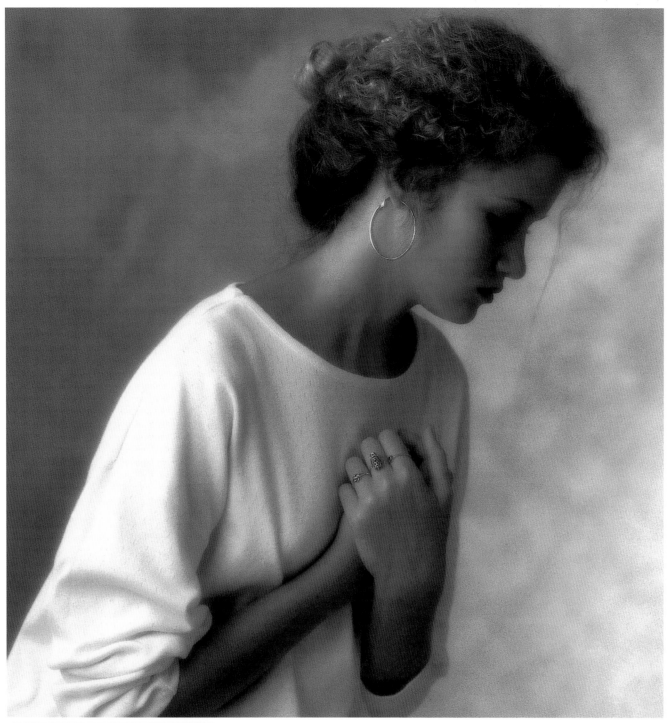

Photograph by Tim Kelly. Diagram by Shell Dominica Nigro.

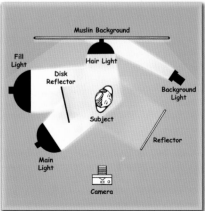

ally hand-painted). This equipment serves for individuals and groups, all photographed using an 8" x 10" camera with a 5" x 7" back.

Tim Kelly. The main light in Tim Kelly's studio is a Photogenic Powerlight housed in a 3' x 4' Larson Soff Box. He will often use this light set to an output of f/11.5. The fill light is a 4' x 6' Soff Box. In many of Tim's lighting sets, he uses the fill and key on the same side of the camera. The fill is typically set for an output of f/8 to f/8.5, roughly a stop less than the key light. The hair light is another soft light, a Larson 10" x 30" Soffstrip with louvers. This light is typically set to f/11. There's a round disk on a mini boom arm,

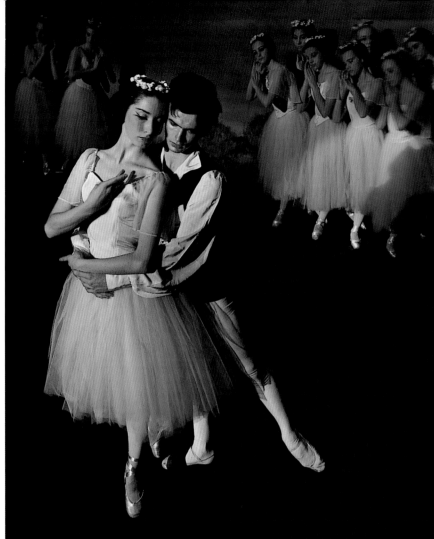

TOP—Photograph by Bill McIntosh.
BOTTOM—Photograph by Monte Zucker.

useful as a gobo, positioned near the main light. He will also use a small light with a grid spot to spotlight the background. A large silver reflector acts as a secondary source of fill light since, as described here, the fill light and key light are both on the same side of the subject. The reflector provides an f/5.6 to f/8 output, as needed.

Bill McIntosh. Since Bill shoots so many of his portraits on location, he uses as many strobes as are required to light the room, the background and the subject. He uses Calumet Travelite strobes frequently, and his main light is often in a 31" umbrella. His fill light is normally a 32" umbrella. Other lights may be used diffused or in their parabolic reflectors, depending on his needs. He will often use lights in reflectors with barn doors, particularly where he wants to increase the contrast of the light in a specific area of the portrait or on the subject. He has been known to use as many as twelve strobes to light such huge areas as the stage of an opera house or the gallery of a museum. McIntosh is also a big proponent of barebulb flash, but often as an outside main light source with daylight used as a fill light.

Monte Zucker. Monte's favorite portrait lighting system is a Portamaster PM08 power pack from Photogenic with four light heads: two PM 12s and two PM 10s. In Monte's words, "I actually use two Portamasters. One controls my lighting in the subject area, while the second one is used for my fill light. At the same time, of course, it also acts as a back up for the first Portamaster system. I plug two light heads into the power pack and

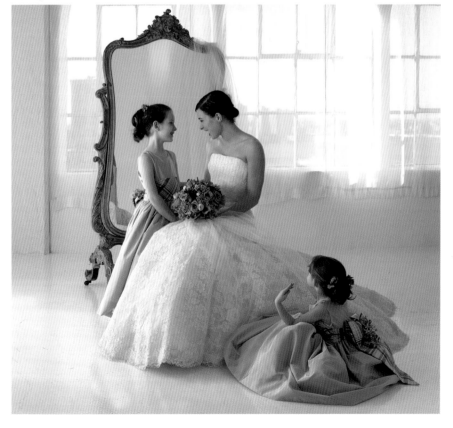

position one on each side of my subject area. That way, I can turn my subjects in either direction and always have the light in place without having to move it from side to side. One of the two lights is used as the main light. The other becomes a hair light. They are of equal intensity, of course."

Both of these lights are placed in Westcott's Mini-Apollos, a 16" square light modifier with a translucent front and internally silver sides with black on the outside. The two lights are on Westcott boom-arms, allowing him to place the lights anywhere without having to worry about getting the light stands into the picture. The 16" square light source is on the small side, but Monte likes it because it allows the light to spread evenly over as many as five people together.

He has an additional two lights behind his subject. Both of these also plug into the Photogenic power pack. One is used to light the background. The other becomes either a backlight for a bridal veil or a kicker light to highlight the edge of a subject's face.

A fifth light is placed behind the camera. He will usually bounce it into an umbrella for a fill light. He exposes for the main light and keeps his fill light two f-stops lower than his main light.

BELOW—Photograph by Monte Zucker.

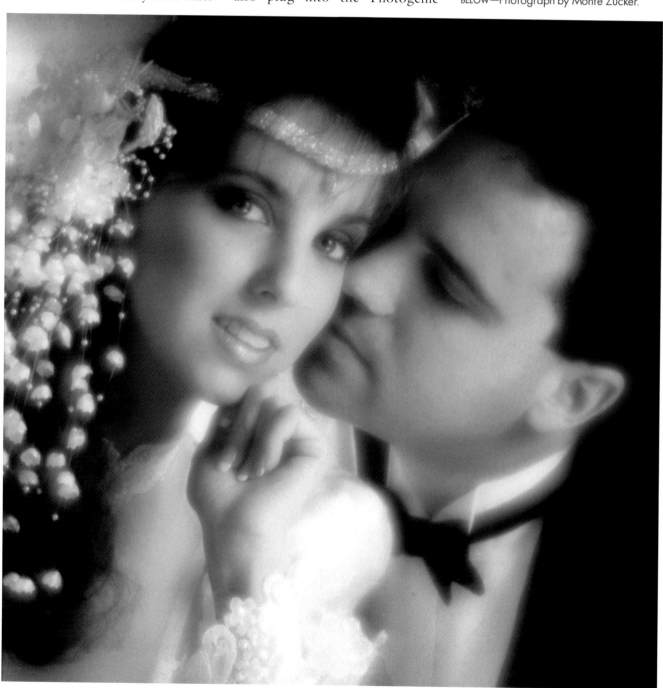

6. Types of Portraiture

The challenges of portrait photography are not, by any means, limited to lighting, posing and composition. From coordinating and arranging the subjects in large group portraits, to working with energetic children in the studio, to creating the flawless look demanded in high-fashion portraits, the specialized subfields of portraiture require unique skills in order to produce top-quality images.

● CHILDREN'S PORTRAITS

Children's portraiture has become highly specialized. Many studios offer fine children's portraiture in addition to their other photographic services, such as fine portraits or weddings. Some photographers, like Tammy Loya, photograph only children. It has become her life's work and she is extremely good at it, treating each new client like a preferred customer.

Use an Assistant. In photographing small children and babies, it is essential to have an assistant and some props handy to attract their attention. Your assistant should be behind the camera and create as much fuss as possible to gain the attention of the child. Soft toys, small rocking chairs, and carriages are all good props—both to keep the attention of the child and to set an appropriate mood. While your assistant is distracting the child, you can concentrate on other elements of the photograph—the lights, the pose, and the setting. You can often redirect the line of the child's head by having your assistant hold up something interesting in sight of the child and

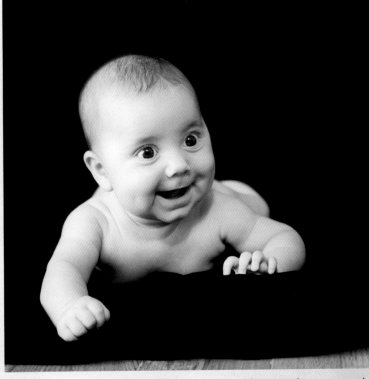

LEFT—Phillip Charis photographs a lot of children in his studio and gallery. Just as with his portraiture of adults, Charis produces extremely high caliber portraits that command high fees. RIGHT—Phil Kramer is one of the nation's leading wedding photographers but he also enjoys making portraits, especially of babies. It is always imperative with infants and small children to have an assistant who can make sure the child is safe and help stimulate the child so that a number of great expressions will be possible in a short period of time.

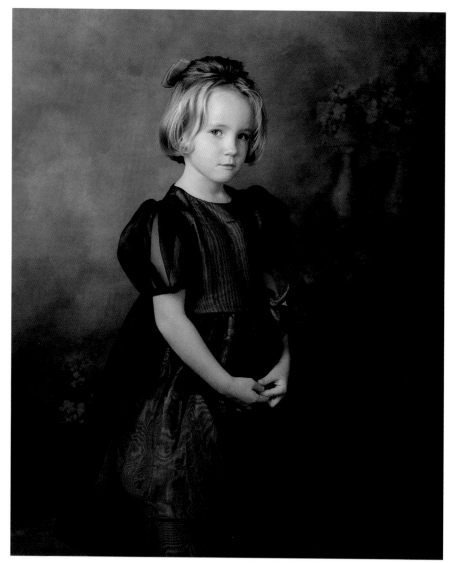

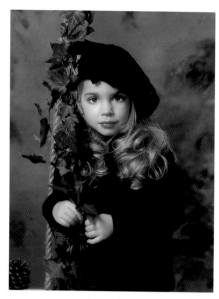

LEFT—Tim Kelly also does fine portraiture of children, using a formal atmosphere and having the children dress in their finest clothes. This beautiful portrait is titled *Emerald Garden* and is one of Kelly's best-known portraits. It is also one of the few examples of broad lighting found in this book. ABOVE—One of the props in Rita Loy's studio is a swing with ivy decorating the ropes. Here, Rita uses it as a prop to photograph this sophisticated little beauty. Softboxes were used close to the little girl for extremely soft light. Rita was careful to light all the gold curls.

move it in the direction that turns the child's head slightly. It is important not to overstimulate the child with props and gags, or the session will likely end prematurely.

Composition. Regardless of which direction the child is facing in the photograph, there should be slightly more room in front of the child than behind him. For instance, if the child is looking to the right as you look at the scene through the viewfinder, then there should be more space to the right side of the child than to the left of the child in the frame. This gives a visual sense of direction. Even if the composition is such that you want to position the child very close to the center of the frame, there

should still be slightly more space on the side toward which he or she is turned.

Lighting. Kids are photographed just as often in the studio as they are outdoors or in the home. The basic lighting setups you will use should be simplified for active subjects and short attention spans. Elaborate lighting setups that call for precise placement of backlights, for example, should be avoided in favor of a single broad backlight that creates an even effect over a wider area. In fact, when photographing children's portraits, if one light will suffice, don't complicate the session by using more.

Children's portrait photographers often have a favorite basic

lighting setup that they use either most of the time (because it works and they like it) or as a starting point (because they're confident in the results it produces).

Many photographers favor the use of one large softbox—4' x 6' and larger—and a secondary smaller softbox to wash their small clients in a soft directional light. The light is large and forgiving and the photographer is not limited to one exact position in which the child must pose.

Other photographers use a single main light in the form of a shoot-through umbrella placed very close to the subject—less than a foot or so away. As was noted earlier, the closer the diffused light

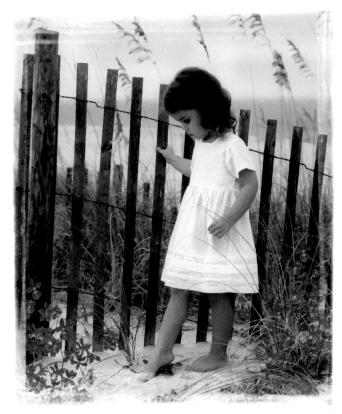

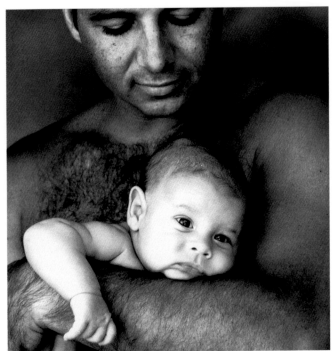

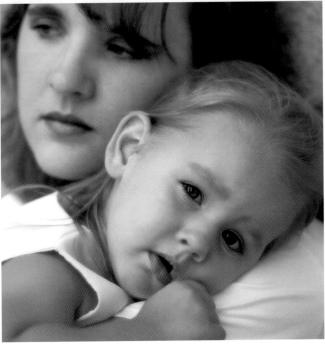

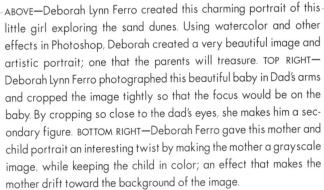

ABOVE—Deborah Lynn Ferro created this charming portrait of this little girl exploring the sand dunes. Using watercolor and other effects in Photoshop, Deborah created a very beautiful image and artistic portrait; one that the parents will treasure. TOP RIGHT—Deborah Lynn Ferro photographed this beautiful baby in Dad's arms and cropped the image tightly so that the focus would be on the baby. By cropping so close to the dad's eyes, she makes him a secondary figure. BOTTOM RIGHT—Deborah Ferro gave this mother and child portrait an interesting twist by making the mother a grayscale image, while keeping the child in color; an effect that makes the mother drift toward the background of the image.

source is to the subject, the softer the quality of the light. Shoot-through umbrellas diffuse direct light at the source, producing large, elegant highlights.

Similarly, some photographers use a softbox in a close position for babies and small children—particularly with a white background, clothing or props. The diffused light of the softbox used close to the set causes a lot of light bounce,

creating an unusually soft, very clean white look.

Tripod and Cable Release. Many expert children's portrait photographers will work with a camera on a tripod and use a long cable release or radio remote, which frees them from being at the camera. This allows the photographer to better interact with the child. In such situations, composition must be somewhat loose in case the child

moves a little. Still, working one-on-one with the child is preferable to talking to the child from behind the camera.

Clothing. Coordinate all of the clothing so that items like blankets and props have colors that complement one another. When photographing children (or any other subject) outdoors, it is important to dress them in clothing that is appropriate to the setting. It would

Often the best location for photographing children is outdoors. Here, Martin Schembri photographed this red-headed beauty out in the open in a field of grass. The hat helps to block some of the overhead light, which can hollow out eye sockets and produce unkind shadows under the chin and nose.

not make sense to photograph a child wearing a three-piece suit next to a babbling brook. Also, in today's less formal world, it is appropriate for children to wear comfortable and sporty clothes in such outdoor settings.

Clothing is really the best prop for a child's portrait. Fine clothing can define a moment (like a christening gown) or a personality (like jeans and a faded cowboy shirt). Clothing makes the difference between upscale and average.

Comfort. With children it's important to let them do what comes naturally, with a minimum of direction. Children will become uncooperative if they feel they are being overly manipulated. Make a game out of this part of the sitting so that the children are at ease and are as natural as possible. It is not necessary to demand a smile. If their smile is not there, you will only increase the child's resolve not to smile by insisting upon it.

● FAMILY PORTRAITS

Family groups taken in the family home show the familiar warmth of everyday life. Outdoor family portraits are also extremely popular and represent a hallmark in the family's history.

The first opportunity for a family portrait arises when the children are young and the parents want a handsome portrait of the nuclear family. The second big opportunity for a family portrait arises when the members of the extended family return home for a visit. This will

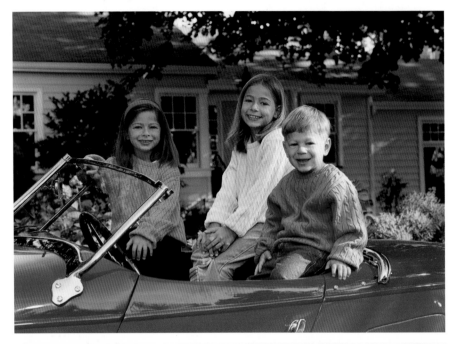

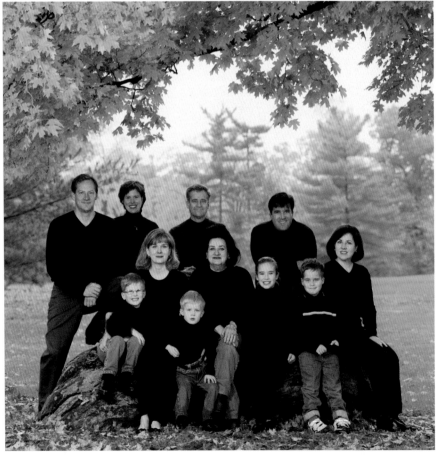

TOP—David Bentley made sure the three kids were dressed similarly, but not exactly alike. All three have brightly colored crew-neck sweaters. The poses are relaxed and they were photographed in the family hot rod. David used a barebulb flash to open up the shadows. Even though the boy is in partial sunlight, he does not dominate the scene, because he is also the smallest of the three. BOTTOM—Color coordination is the key to this family group portrait's success. No doubt instructions were to wear all black. The kids, of course, had no black pants so they all wore jeans, which the photographer coordinated along with the adult who also wore jeans. Anthony Cava made this portrait. He had the family pose under the tree, which blocked the overhead nature of the open shade. He then used flash-fill to add some sparkle to the faces of the family members.

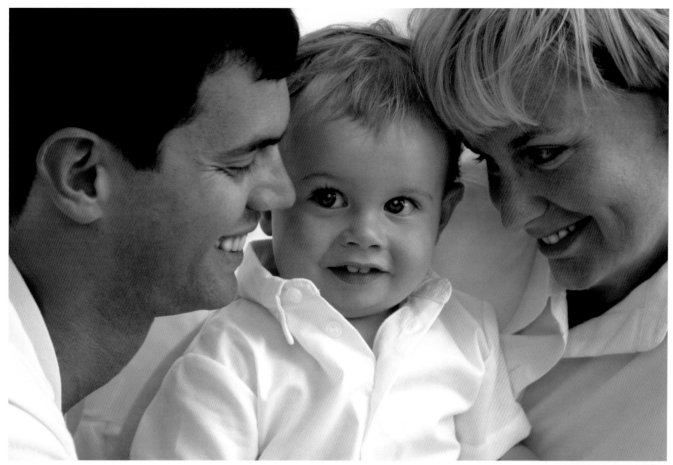

ABOVE—Everything about children is so much smaller than adults. In this family portrait, Monte Zucker moved in close and cropped Mom and Dad so that the small child would "read" well in the final image. RIGHT—Bill Duncan also had his family group dressed in black. You can see some of the compositional shapes—mostly triangles—are helping to unify the composition. The background, which was several stops brighter than the family, was burned-down in printing.

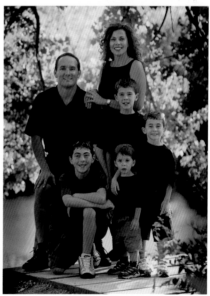

usually include grandchildren and multiple families.

Clothing. Whether the session will be on location or at home, it is crucial to coordinate the clothing of the family members. Probably the biggest single reason families don't like their portraits is because of what the people are wearing. As one photographer puts it, "They never listen to me no matter how adamant I am about coordinating the clothes. I am constantly amazed at what they show up in."

Others, like Bill McIntosh, are masters of the coordinated environment. Here's what he has to say about planning. "No matter how good your artistic and photograph-ic skills are, there is one more element required to make a great portrait—color harmony."

In McIntosh's photographs the style and color of the clothing all coordinate. He says, "I have ensured these suit both the subjects and the environment chosen." Bill makes sure everything matches. "Time is well spent before the sitting discussing the style of clothing—formal or casual—and then advising clients of particular colors that they feel happy with and that would also create a harmonious portrait."

Solid color clothes, in cool or neutral shades with long sleeves always look good. Cool colors, such as blue and green recede, and warm colors, such as red, orange, and yellow, advance. Cool colors or neutral colors (such as black, white, and gray) will emphasize the faces and make them appear warmer and more pleasing in the photographs.

Your entire group's garments should blend. For example, all of

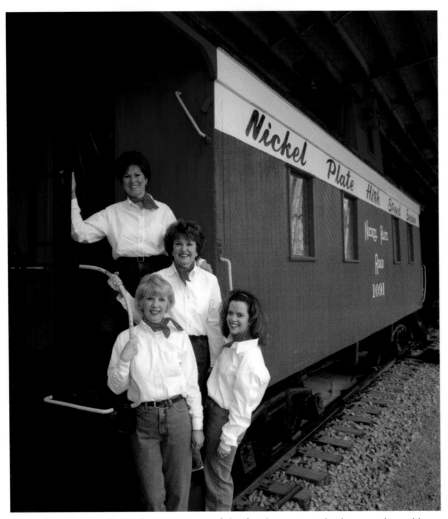

Michael Ayers coordinated every aspect of this family group, right down to the red bandannas that match the bright red train car. His composition is flawless too. Each woman is at a slight angle except for the woman in the very middle. Notice the unifying shapes that are formed: a diagonal line and two triangles.

the family-group members should wear informal or formal outfits. It's easy when photographing the wedding party because all the subjects are dressed identically and formally. Half your battle is won. It is difficult to pose a group when some people are wearing suits and ties and others are wearing jeans and polo shirts. Shoe styles and colors should blend with the rest of a person's attire: dark outfits call for dark shoes and socks.

Posing. Is it better to pose by age, importance or size? This is a question of considerable debate among group-portrait photographers. Some say to concentrate on

logically organizing the groups and subgroups of a family. The reasoning is that these subgroups (such as first son, his wife and two kids) want to be photographed at the same session, thus doubling sales. Some feel, the family is more cohesively arranged if organized by age (grandparents in the middle, with their children adjacent and the grandchildren and their families in the outer realms of the group). One can also arrange subjects by size within the subgroups for the most pleasing composition.

Many photographers feel that posing by size and shape creates by far the most interesting and attrac-

tively posed group. This is certainly true for weddings where groups, formal or informal, can be arranged in any number of ways as long as the bride and groom are central. This method also affords the photographer the most flexibility to hide and flatter individual members of the group.

Sometimes the group composition will even be dictated by what the people are wearing—such as in cases where an unmatched article of clothing needs to be hidden or where subgroups are defined by their unique clothing.

Lighting. There are two basic rules for photographing families. First, everyone in the group must look great! The other rule of thumb is that the lighting, regardless of the type, must be even all across the group.

Family groups photographed in the home are best photographed with some type of soft light, usually umbrella flash. Multiple umbrellas should be used and the light reading across the group should be identical—from left to right and from front to back. Each person should be well posed and should occupy his or her own space. Shadows should fall behind the people and not on the person seated next to them. The design of the group should be logical and it should incorporate pleasing design elements such as triangles, curved diagonals, and so forth.

A family group photographed outdoors must meet the same two criteria—everyone should look great and the lighting should be even. If using available light with flash fill, it may be necessary to coordinate more than one flash so that the entire group is evenly lit. This can be accomplished using strobes that are "slaved" together

with radio remotes. These are devices that are triggered by the camera but will fire the flash units remotely, due to the transmission and reception of a radio signal.

As many of the great photographs in this book illustrate, the best time of day for making great group pictures is just after the sun has set. The sky becomes a huge softbox and the effect of the lighting on your subjects is soft and even, with no harsh shadows.

● GROUP PORTRAITS

Planning. Photographing groups can be a daunting experience. Therefore, while planning is practical for any sitting, it is *essential* with large groups. The good group photographer knows the makeup of the group, the reason for the portrait and has several ideas of how to organize the group. He or she also has an idea of what lenses and lights will be needed, and how to control the situation when the people start coming through the door.

Ken Sklute is a master of great group portraits. Here, the bridal party is having fun tossing the groom around. All faces are visible and each person looks great. It is certain that Ken said something very funny to get these great expressions. Notice too that the girls at the ends of the group are facing in to unify the group and almost all of the heads are at a different height for visual interest.

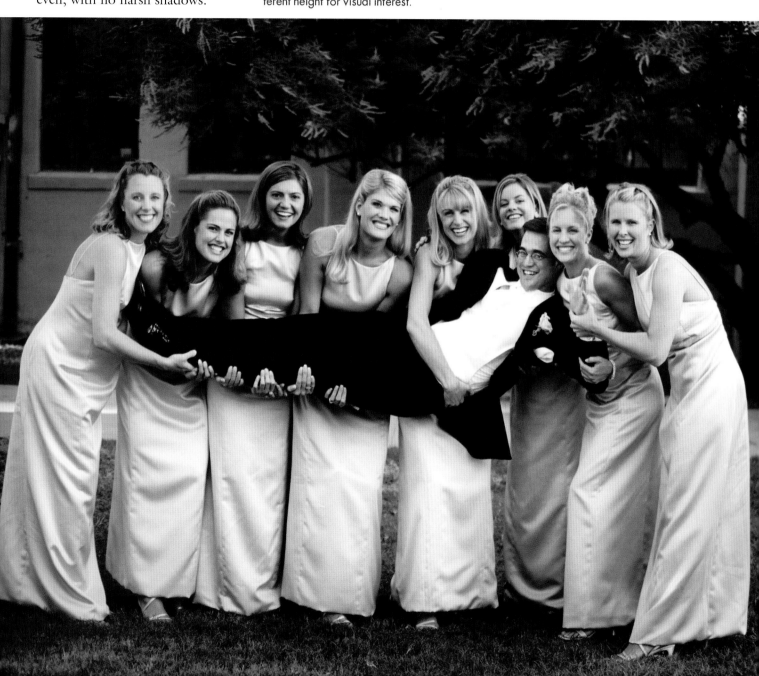

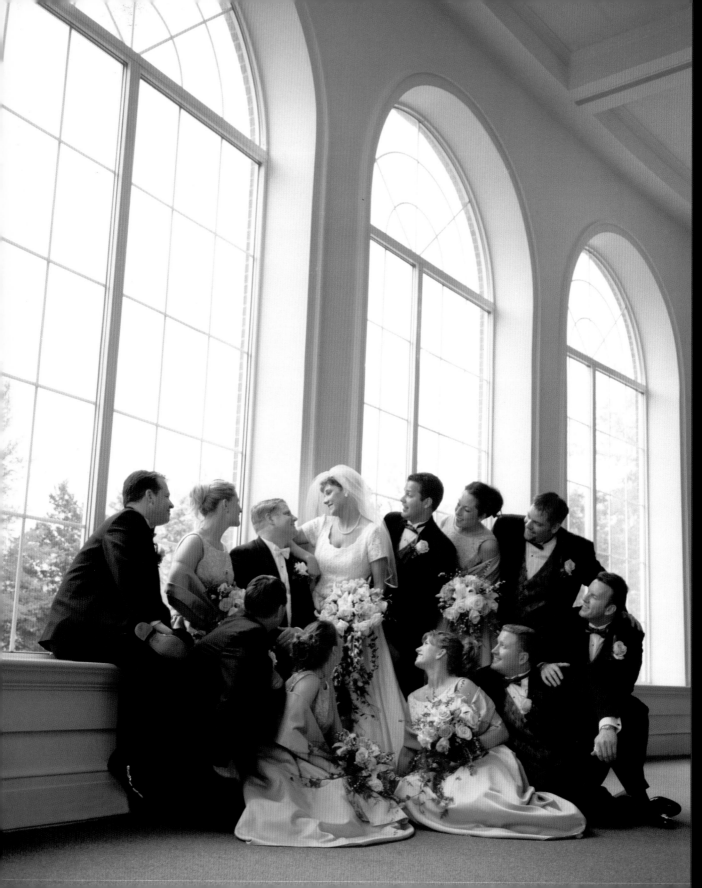

FACING PAGE—In a portrait with twelve people, it is extremely important to control as many of the variables as possible. In this portrait of a bridal party, Michael Ayers created an interesting composition, which has all of the members of the bridal party looking in at the bride and groom. Each person occupies a space within the portrait and the expressions are great. The portrait is made by available room light and bounce flash. RIGHT—Ken Sklute created this beautifully composed formal group with perfect symmetry. Two groups of five people flank the bride and groom. Members of the bridal party are arranged to form two sets of intersecting diagonal lines, which heighten the visual interest of the design. The bride and groom are posed close together with heads at the same height. Camera diffusion and flash fill add just the right amount of romance and formality to the portrait. Note too how each person is posed elegantly and at a slight angle to the camera.

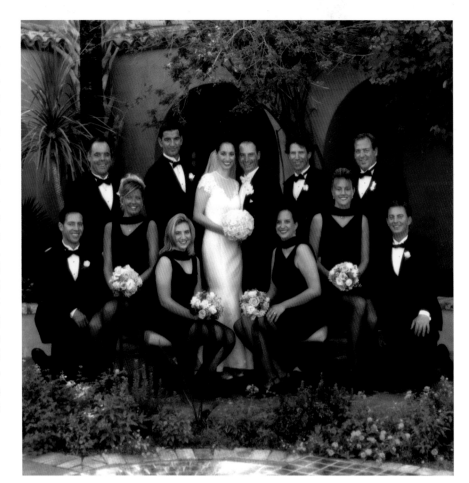

It is extremely important that the photographer be in charge! Without a leader, the group will fall into chaos. The photographer serves as the director, coach and friend—and everyone will look to him or her to determine what they should do next. It's also a great idea for the photographer to employ an assistant. This is especially true with large and unwieldy wedding groups, where champagne has been liberally ingested.

When giving directions, it is always better to *show* than it is to *tell* people how they should pose. A good group photographer will act out how he or she wants the person to pose. It's much easier than describing the pose and it takes less time. A good group photographer also knows how to communicate with people in the group. Flattery, praise, and humor are all positive tools for building a great group. If

closeness is what is desired, then the photographer needs to "talk them into it."

Groups and Subgroups. When creating a group portrait, one of the first things to consider is the make-up of the group. Are they family members, perhaps posing for a family reunion photograph? If that is the case, how does the group break into subgroups? Determine the best logic for arranging the group and place them together. Consider the sizes of each person and how they will come together to create a pleasing composition. Perhaps all the grandchildren will be grouped together rather than with their respective parents.

Great group portraits should have a style and rhythm. They should display direction, motion and all the visual elements that are found in fine portraits and in art. These pictures possess the means to

keep a viewer looking and delving long after the visual information in the picture is digested.

For this reason, no two heads should be on the same level when next to each other, or directly on top of each other. This is only done in team photos, as a rule. Not only should heads be on different levels, but subjects should be as well. In a group of five people you can have all five on a different level, for example: one seated, one standing to the left or right, one seated on the arm of the chair, one kneeling on the other side of the chair, one kneeling down in front with their weight on their calves. Think in terms of multiple levels. This makes any group portrait more pleasing.

Master photographer Norman Phillips likens a photographer designing a group portrait to a florist arranging flowers. He says, "Sometimes we might want a tight

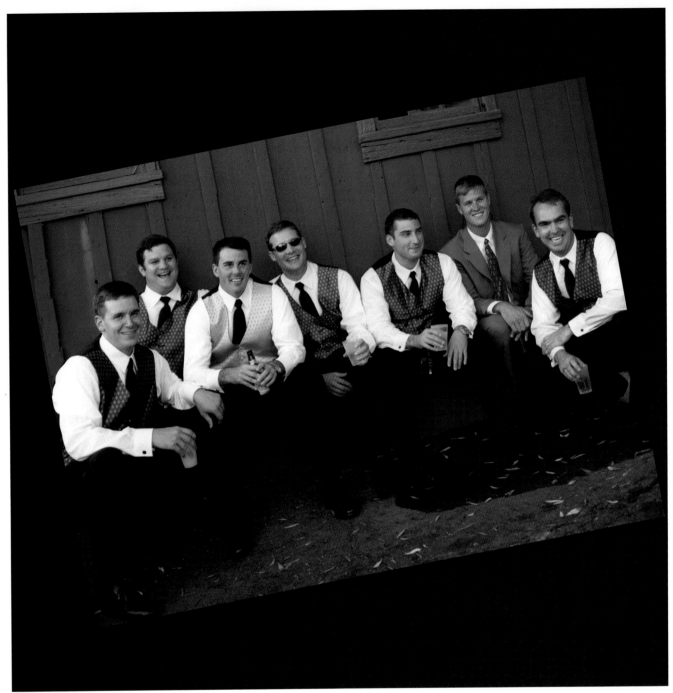

This is a very informal group portrait of the groomsmen and groom. Notice the two men on the ends of the group are posed farther forward and leaning in to act as "bookends" to the group. In order to get more dynamics into the image, Heidi Mauracher tilted the image on the album page so the image would read as a diagonal.

bouquet of faces. Other times we might want to arrange our subjects so that the group looks interesting apart from the dynamics of the people in the group." In other words, sometimes the design itself can be what's important.

An additional consideration is proximity. How close do you want each member of the group to be? Phillips relates proximity to warmth and distance to elegance. A tightly arranged group where members are touching implies closeness, but opening the group up provides more freedom to introduce flowing lines and shapes within the composition. Whether tightly or loosely

grouped, the results should be consistent. Don't have some people close together and others far apart. There should be roughly an equal distance between each member of the group.

Planes. Establish one or several planes in which to place individuals in the group. These planes will simplify the lighting and allow the photographer to include everyone within the camera's range of focus. Sometimes, a setting, such as a

staircase or a gentle sloping hillside, can provide you with a natural organization of planes. Designing the group so that those posed in the back are as close as possible to those in the front helps to ensure that the plane of focus will cover the front row as well as the back row. There is nothing more distracting than having only some of the people in a group sharply focused. Remember, a group portrait is only as good as each of the individuals in the portrait. You should be able to look at each person in the portrait and ask, "Could each of these individual portraits stand alone?" If the answer is yes, then the photographer has done a good job.

Final Analysis. Once the group is composed, it is essential to do a once-around-the-frame analysis, making sure poses, lighting and ex-pressions are good and that nothing needs adjusting. Each person should be checked in the viewfinder and the perimeter of the group scanned for obvious flaws (like poles growing out of people's heads). A good group photographer can scan the frame quickly—two quick scans are all it takes.

Couples. The simplest of groups is two people. Whether the group is a bride and groom, a brother and sister, or grandma and grandpa, the basic building blocks call for one person slightly higher than the

LEFT—The simplest of groups is two people. Here, Charles Maring captured the bride and groom in an intimate pose, but the groom is unaware of Charles. The bride seems to exude radiance and joy on this most special day. The tilt of the portrait and the out-of-focus background add to the beauty of this simple image. Maring used flash-fill to add twinkle to the bride's eyes. BELOW—This elegant portrait by Joe Buissink is reminiscent of a '40s style portrait. Taken at a wedding, this is a wonderful portrait because of the intensity and depth of the expressions. The tight cropping on the print focuses your attention on these wonderful faces.

Wedding photojournalist Becker also makes nicely posed groups. Here Becker tilted the camera to give it a diagonal line and then photographed the bride and her maids with heads close together to form a nice tight line. Everyone is angled in, facing the bride and the line of their eyes is parallel throughout. Backlighting produces beautiful highlights on the girls' shoulders, while on-camera flash-fill gives a nice sparkle to their eyes and lips.

other. Generally speaking, the mouth height of the higher subject should be at the forehead height of the lower subject. Many photographers recommend a mouth-to-eyes height arrangement as the ideal starting point.

Although two people can be posed in parallel positions—each with their shoulders and heads turned the same direction, as one might do with twins, for example— a more interesting dynamic can be achieved by having them pose at

45-degree angles to each other so their shoulders face in toward one another. With this pose you can create a number of variations by moving them closer or farther apart.

Another intimate pose for two is to have two profiles facing each other. One should still be slightly higher than the other, to create an implied diagonal line between their eyes, which also gives the portrait direction.

Groups of Three. A group portrait of three is still small and intimate. It lends itself to a pyramid or diamond-shaped composition, or an inverted triangle, all of which are pleasing to the eye.

When designing a small group, don't simply adjust the height of the faces so that each is at a different level. Use the turn of the shoulders of those at either end of the group as a means of looping the group together.

With the introduction of a third person to the group, the interplay of lines and shapes in good group design will start to become apparent. As an exercise, plot the implied line that goes through the shoulders or faces of the people in the group. If the line is sharp or jagged, try adjusting the composition so that the line is more flowing, with gentler edges. A simple adjustment, like turning the last or lowest person in the group in toward the group, can have a unifying effect.

Groups of three and more allow the photographer to draw on more of the available elements of design, in addition to the design elements of the group itself. The accomplished group photographer will incorporate architectural components, or natural elements, such as hills, trees, shrubs, flowers, gates, archways, furniture, etc., into the group portrait.

Groups of Even Numbers.
Group specialists will tell you that even numbers of people are harder to pose than odd. Three, five, seven or nine people are much easier to photograph than groups of four, six, eight or ten. The reason is that the eye and brain tend to accept the disorder of odd-numbered objects more readily than even-numbered ones.

Large Groups. The bigger the group, the more the photographer must depend on the basic elements of group portrait design—circles, triangles, inverted triangles, diagonals and diamond shapes. The photographer must work to highlight and accentuate lines, real and implied, throughout the group.

With bigger groups, the photographer will try to "link" shapes by using a person who is common to both subgroups. For example, you can link two triangular groups of three people by adding a seventh person between the two main shapes. Overlapping subgroups is one of the ways to make visual sense out of large groups. Angling subgroups toward each other also helps to unify large sections of a group composition. Just as the implied lines of design become apparent to the photographer who looks for them, so the shapes inherent in grouping people will also become second nature once the photographer begins to think in these terms.

The photographer should constantly be aware of intersecting lines that flow through the design. As mentioned previously, the diagonal is by far the most compelling visual line and can be used repeatedly without fear of overuse. The curving diagonal is even more pleasing and can be happily mixed with sharper diagonals within the composition.

● THE ENVIRONMENTAL PORTRAIT
Making great environmental portraits takes experience, as well as an ability to see and control natural light. With a minimum of equipment, it is possible to capture natural-looking portraits that possess as much sophistication as a classically lit studio portrait.

Portraits are best made in shade—but not out in open shade, which is overhead in nature. Instead, look for an area that has an overhead blocker, like a porch that is open on the sides. In this situation, the shade filters in from the side, not from overhead, and provides a gentle direction to the light. If no overhead blocker is available, have an assistant hold a gobo directly over the subjects. These measures will serve to block the

Bill McIntosh is a master of the environmental portrait. This image was made in 1949. The depth of field here is almost nonexistent as everything past the boy falls out of focus. Lighting direction was achieved in part by the dark wood to the boy's left, which provides a bit of a ratio to the lighting. The catchlights, perfectly round, were added to the print.

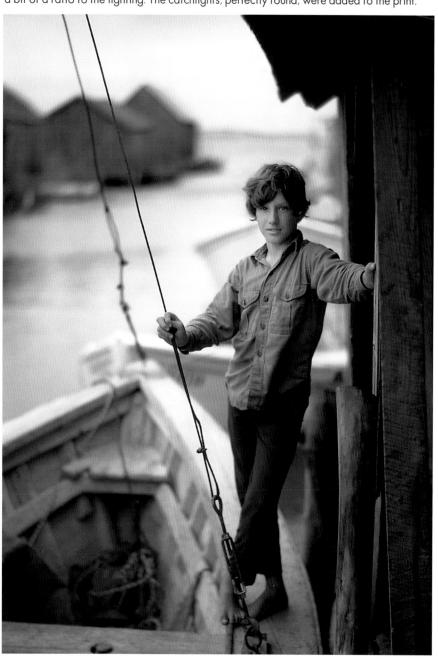

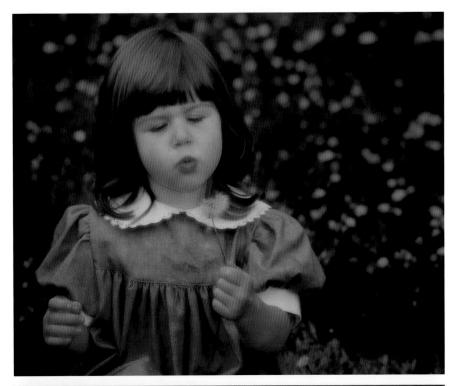

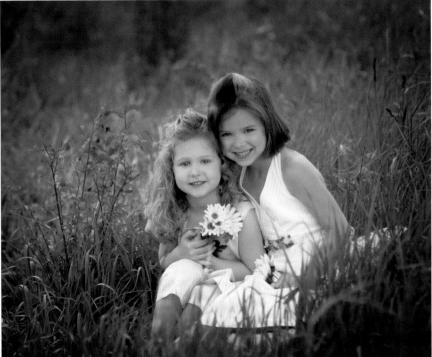

TOP—Frances Litman created this lovely portrait in a field of daisies using available light to illuminate the little girl. She also used a soft-focus filter to cut scene and lighting contrast and to add a dreamy edge to everything. BOTTOM—Larry Peters photographed these two little girls in an open field. To counteract the overhead nature of the open shade, he used an off-camera diffused flash to provide a lighting pattern to the faces. The image is backlit as you can see by the highlights in the girls' hair. The flash fill produces beautiful modeling on their faces and large catchlights in their eyes.

overhead light and reduce the possibility of "raccoon eyes" on the subjects.

If you are forced to work in open shade, it is necessary to fill in the shade with a frontal flash or reflector. If shooting a couple, a reflector held close to and beneath your subjects will help to fill the shadows created by the overhead quality of open shade. If photographing more than two people, then fill flash is called for. The intensity of the flash should be about equal to the daylight exposure. In other words, if the daylight exposure is $^1/_{125}$ at f/8, the strobe should be set to an output level of from f/5.6 to f/8. At this setting, the flash will be barely noticeable, but you will see catchlights in the eyes and the shadows will be minimized. It is important that you use a shutter speed that is slower than or equal to your X-sync speed (the speed at which cameras using focal-plane shutters sync with electronic flash). Otherwise, you will only partially expose the frame to flash. X-sync speed is not a factor when using cameras with lens shutters, which sync with electronic flash at all speeds.

The best time of day for making great portraits is just after the sun has set. The sky becomes a huge softbox and the effect of the lighting on your subjects is soft and even, with no harsh shadows. There are, however, three problems with working with this great light. First, it's dim. You will need to use medium to fast films combined with slow shutter speeds, which can be problematic. Working in subdued light also restricts your depth of field by virtue of having to choose wide apertures. The second problem in working with this light is that twilight does not produce catchlights. For this reason, most

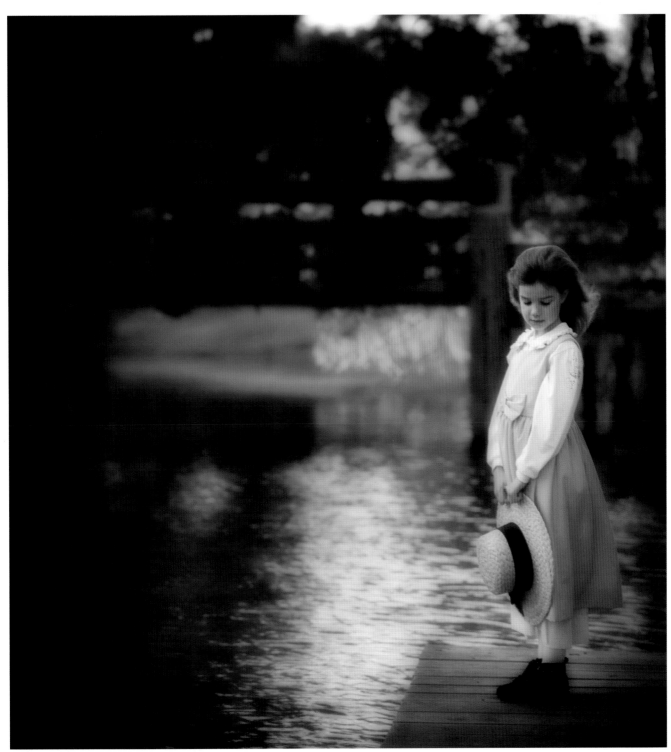

This wonderful portrait by Martin Schembri employs diffusion for a painterly feel. The image uses no auxiliary light, but the overhead nature of the open shade is overcome by having the girl look down so her hair blocks some of the light on her face. There is nice direction to the light coming in from the side. The pose is simple and childlike. The diffusion, which is more pronounced in the background, was applied in Photoshop.

photographers augment the twilight with some type of flash, either barebulb flash or softbox-mounted flash that provides a twinkle in the eyes. Thirdly, twilight is difficult to work with because it changes so rapidly. Each minute following sunset or prior to sunrise produces changing light levels. Meter repeatedly in the changing light and

adjust flash output, if using fill flash, to compensate.

A very popular form of fill light is barebulb flash, a portable flash unit with a vertical flash tube that fires the flash a full 360 degrees. You can use as wide a lens as you own and you won't get flash falloff. Barebulb flash produces a sharp, sparkly light that is too harsh

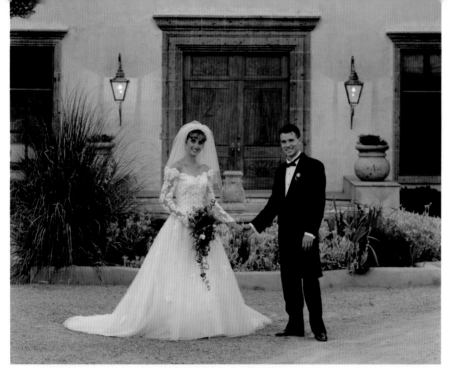

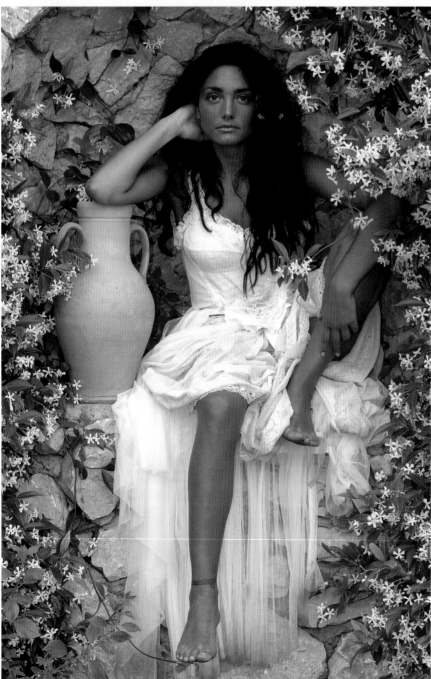

TOP—Frank Frost is a master of using available light as his only light source. He shoots with medium format and a tripod and waits until the sun begins to set so that the facing sky becomes a huge open softbox. He will often shoot at exposures as long as ⅛ second. BOTTOM—Award-winning wedding photojournalist Joe Buissink created this lovely and unique outdoor portrait of a barefoot bride sitting against a flowered wall. Joe used flash fill to get some twinkle in her eyes and added a canvas effect to the image, post-capture.

for almost every type of photography except outdoor fill. The trick is not to overpower the daylight, otherwise the light will produce its own set of shadows. It is most desirable to let the daylight or twilight backlight your subjects, capitalizing on a colorful sky background if one exists, and using barebulb flash to fill the frontal planes of your subjects.

Some photographers like to soften their fill flash, using a softbox instead of a barebulb flash. In this type of situation it is best to trigger the strobe cordlessly, using a radio remote trigger. This allows you to move the diffused flash out to a 30- to 45-degree angle to the subjects for a dynamic fill-in. In these situations it is wise to equal or overpower the daylight exposure slightly so that the off-angle flash acts more like a key light. For larger groups it is often necessary to use several softboxes, or to use a single one close to the camera for more even coverage.

● THE FASHION PORTRAIT

The fashion portrait is quite different from conventional portraiture. Posing is much more relaxed, lighting is more frontal in nature, and composition favors closeup images with very tight cropping. It is, nev-

ertheless, a popular portrait style offered by many studios—particularly for high school seniors and brides.

Lighting for fashion portraits is usually ultra-soft, featuring the mainlight placed directly over the lens and a reflector used just beneath the lens. The main light is very close to the subject for the softest effect. Makeup is used to provide contouring and dimension in the face, since frontal lighting relieves the facial shape of much of its roundness. Cheekbones are shaded, as is either side of the nose, to give a better sense of shape.

The fashion portrait accentuates the subject's beauty, which is enhanced using makeup. The best features are highlighted and idealized through these cosmetics, as well as with post-capture retouching.

Posing basics, such as a well defined head and neck axis, are not as important in the fashion portrait. Instead, you will see many fashion portraits posed with the shoulders parallel to the ground and facing the camera, and with the face on the same plane.

TOP—Phil Kramer produced this very high key image by filling the backlit image with a large reflector and then overexposing the image. The result is an image composed of almost all whites, including the background. The lighting pattern on the bride's face is frontal and flat, obscuring much of the contouring, yet it is a very hip image. BOTTOM—Don Emmerich created this lovely portrait using on-axis diffused lighting for a fashion effect. You can see by looking at the large catchlights in the model's eyes where the softbox was positioned—over the lens, slightly to the right of camera. A reflector is used to camera left. Despite the frontal nature of the lighting, the face shows excellent contouring and even the hint of a loop lighting pattern.

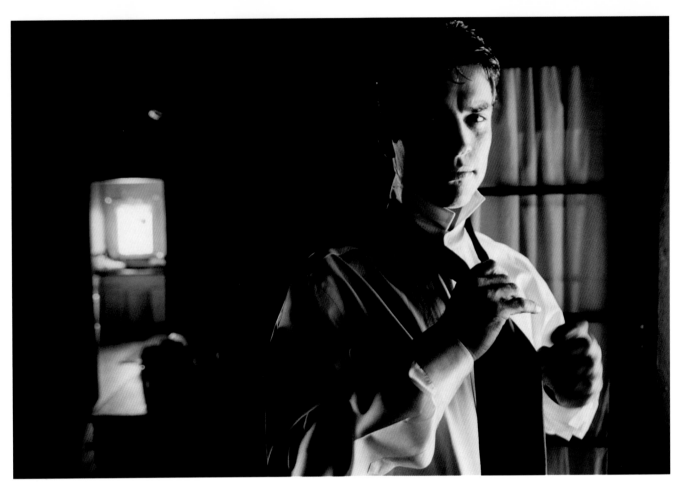

ABOVE—Joe Buissink created this dramatic fashion-type portrait of the groom getting ready for his big day. Men's fashion photographs are often made with strong contrasty light and no fill. RIGHT—A very unusual pose and nearly blown-out highlights make this Martin Schembri bridal portrait truly unique. The portrait features shadowless lighting and a star-shaped composition. Martin burned down the top two corners to balance the outstretched hands in the lower portion of the image. It's interesting how much of the highlight information has been removed without it affecting the communication values of the image.

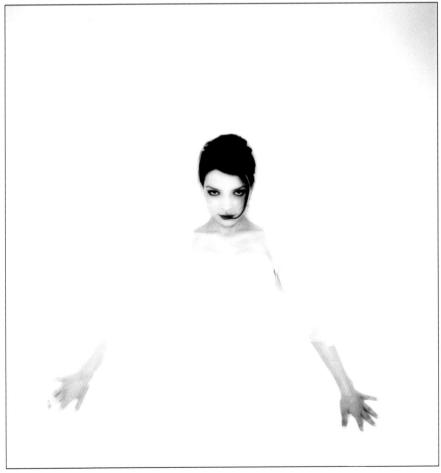

Techniques for men's fashion portraits include tilting the camera, ultra-closeup views, and very casual posing. It in not uncommon for men to have makeup applied for this typeof portrait. These portraits are popular for high school seniors and for portraits of the groom as part of the wedding-day coverage.

● THE EXECUTIVE PORTRAIT

The modern-day executive does not often have the time needed to make a top-quality portrait. Often only ten or fifteen minutes will be given—hardly enough time to control the many nuances of a fine portrait. It is advisable to know as much about the subject and the offices as possible before the sitting is scheduled. Those who shoot executive portraits frequently make it a point to visit the offices a day or two beforehand or, if that is not possible, try to be there at least an hour or two before the sitting time to become familiar with the setting.

With on-location portraits, such as executive portraits, it is often necessary to drag all of the lighting equipment you might need with you. Not only does the executive have to be well lit but the surroundings have to appear opulent. It is essential with busy executives to have everything set up in advance so that the photographer can begin the sitting as soon as the subject arrives. An assistant is invaluable and can serve as a stand-in subject so that you can basically set the portrait lights before the executive arrives. In many cases, the photographer will have only enough time to grab a few quick exposures before the subject has to leave.

Typically, the subject is placed within the scene in a way that puts him or her at the center of attention. That doesn't mean in the cen-

ter of the frame, but at the focal point of everything in the scene. If there are large foreground or background elements, they should not be lighted more brightly than the main subject.

The setting should be typical to the executive. If the executive is a museum curator, for example, photographing him in a gallery surrounded by works of art is an ideal choice. The setting should be an integral part of what that person is and does. The setting also lends itself to a dramatic image because of the foreground and background

Much of the executive portrait market has been taken over by the commercial photographer, who will often be responsible for all of the annual report images requested by a corporation. However, Bill McIntosh continues to make fine executive portraits, like those seen above, for paying clients. He will often take every light he owns on an assignment in order to light the environment of the professional.

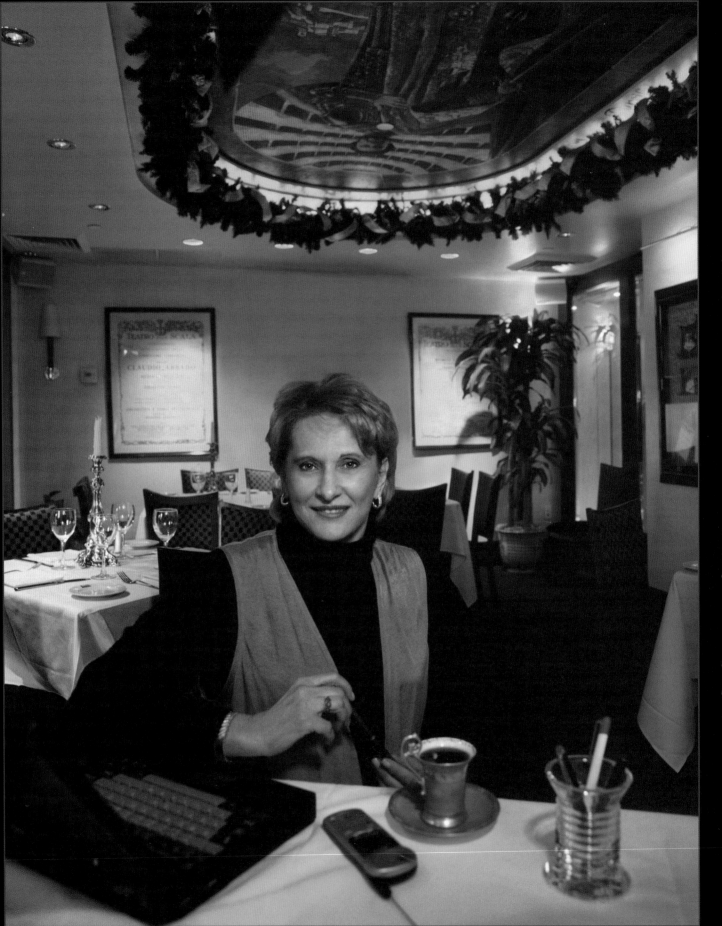

possibilities that are inherent in the composition.

Using a wide-angle lens and getting in close may be the only way to tie in the surroundings and the subject. There may be limited space, as well, making a wide-angle a necessity. If the subject is in an office, it is at times advisable to shoot into the corner of the room so that the con-verging lines of the space help focus attention on the subject.

By placing the subject prominently in the middle ground of the composition, you have the flexibility to look deeply into a dramatically lit background that will frame and define the main subject. This is a trait of many of Bill McIntosh's executive portraits. McIntosh often photographs busy executives in their workplace and is known for his ability to fully light the surroundings, while still producing elegant lighting on his subjects. He will often use as many as eight lights in parabolic reflectors with barn doors to spotlight specific areas of the room. These areas will, by necessity, not be as bright as the

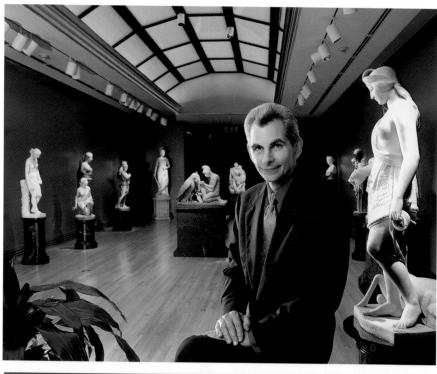

ABOVE, LEFT (TOP AND BOTTOM), AND FACING PAGE—Bill McIntosh is obsessive about incorporating background elements in perfect focus (see the portrait of the fighter pilot) into his executive portraits. Because of this, he always shoots on a tripod and is a master at making long exposures. When the background is pertinent to what the professional does, McIntosh often uses wide-angles to include all of the background area. Placing his subject dead center in the frame helps avoid distortion with these wide-angle shots.

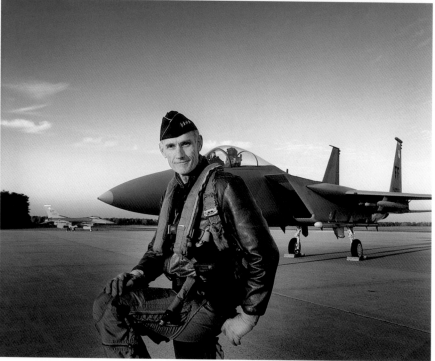

subject lighting, for which he often uses umbrellas. The lighting ratio is usually higher than normal in McIntosh's executive portraits because of the dramatic nature of the lighting. He also feels the high ratio adds mystique to the portrait and provides a better sense of depth and presence.

McIntosh's executive portraits are also known for "scenes within the scene" that are enjoyable to look at but don't detract from the overall portrait. His executive portraits are often made at very slow shutter speeds—$\frac{1}{15}$ or $\frac{1}{8}$ of a second—so that he can incorporate as much of the existing room light as possible. He shoots on daylight-balanced film for the strobes and allows the room light to "warm up" the image. In some situations, the length of the ambient exposure will require that he extinguish the modeling lights of the strobes so that he does not record their accumulated light as well as the ambient room light. This also guarantees that the subject will be lit only by strobe. Because he often shoots at small apertures and long shutter speeds, his portraits possess incredible depth of field, with the plane of sharpness often extending from the subject to a background that might be fifty or more feet away.

● THE WEDDING PORTRAIT

The accomplished wedding photographer must also be a talented portrait photographer. On the wedding day there will be the opportunity for a number of formal portraits—the bride, the groom, the bride and groom, the wedding party, the families, and so on. All of these wedding portraits, although photographed under a variety of

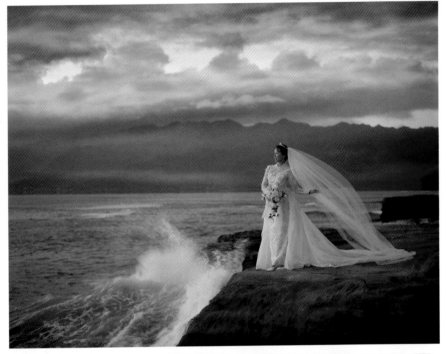

TOP—When the traditional portrait is done as well as this it can be breathtaking. Don Emmerich combined all the right elements—gorgeous sky and seascape, gentle breeze, perfect light, and a beautiful bride in a classic pose—to execute a perfect bridal portrait. BOTTOM—Today's bride and groom don't necessarily want the traditional bridal portrait. They prefer something a little more "edgy." In this portrait entitled *Groom and Goddess* Gigi Clark captured a highly imaginative portrait that suited her clients.

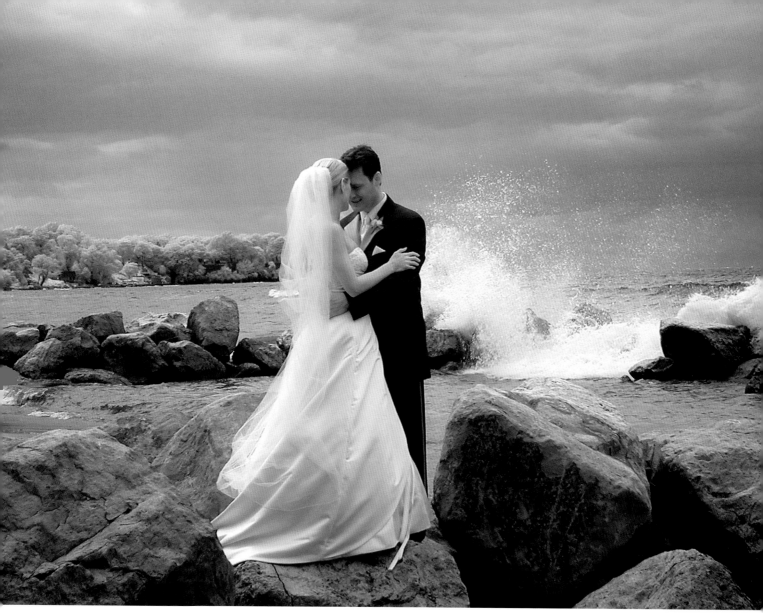

Patrick Rice captured this delightful portrait of bride and groom in digital infrared. The sweep of the gown almost makes it look as if the couple is dancing by the water's edge. It is an intimate and formal pose, but has a spontaneity that is appealing.

light sources and in different locations, should subscribe to the tenets of sophisticated posing and elegant lighting.

There are many excellent opportunities for making wedding portraits. Following the ceremony, the bride and groom should be available, if only for a brief time (most photographers will get what they need in under ten minutes). In addition to a number of formal portraits of the bride and groom—their first pictures as man and wife—this is also a good time try to

make whatever obligatory group portraits the bride has asked for. Alternately, these can be made later at the reception.

The Bride and Groom. This portrait should be a romantic pose, with the couple looking at one another. While some formal poses are advisable, most couples will opt for the more romantic and emotional portraits. It is important to highlight the dress, as it is a crucial element in the wedding's formal portraits. Take pains to show the form as well as the details of the

dress and train, if the dress has one. This is certainly true for the bride's formal portrait, as well.

Usually, at least two formal portraits of the bride and groom are made, a full-length shot and a three-quarter-length image. The details are important, so the couple should be carefully posed with the bride closest to the camera. The bouquet should be visible—and you should give the bride some guidance as to how to hold it for the best effect. Ask her to keep her hands behind it, making sure it is held high enough to put a slight bend in her elbows, keeping her arms slightly separated from her body.

TOP—Joe Buissink is accomplished at the editorial style of portraiture. Note the relaxed masculine pose, the tousled hair, and the way the groom's clothes fit him. This portrait could have been made for a men's fashion magazine. BOTTOM—Rick Ferro is a master at creating an elegant bridal portrait on location, making it look like it was an elegant studio setting. The pose, reminiscent of the '40s, and the rich detail of the hotel furnishings give this portrait a very expensive quality. An interesting element of balance in the image is the portrait on the wall, seemingly looking back at the bride and even mirroring her pose.

The groom should place his arm around his bride but with his hand in the middle of her back. They should lean in to each other, with their weight on their back feet and a slight bow to their forward knees. When used in full-length bridal portraits, a bent forward knee will give an elegant shape to the dress. With one statement, "Weight on your back foot," you have introduced a series of dynamic lines into the composition.

To display the dress beautifully the bride must stand well. Although you may only be photographing a three-quarter-length or head-and-shoulders portrait, the pose should start at the feet. With the bride's feet arranged with one foot forward, the shoulders will also be at their most flattering, one higher than the other. The bride should be posed at an angle to the lens, as in all formal posing. The most feminine position for her head is to have it turned and tilted toward the higher shoulder. This places the entire body into a very attractive S curve, a classic bridal pose.

The bride should hold her bouquet in the hand on the same side of her body as the foot that is extended. If the bouquet is held in

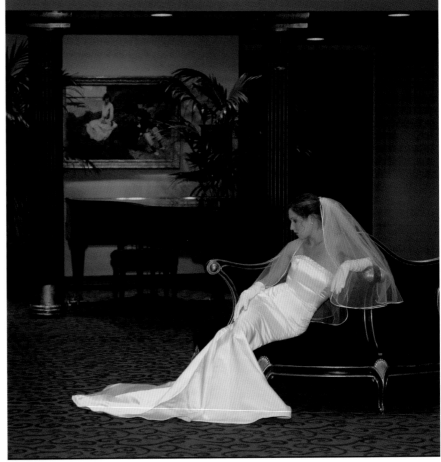

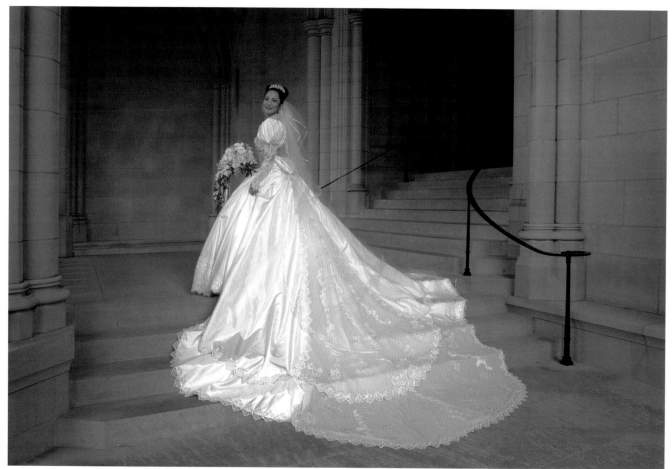

Monte Zucker created this striking bridal portrait in the traditional style. Monte wanted to show the dress in great detail and chose a location that displayed the full length and intricate detail of the train, yet created the means to produce a memorable portrait. The lighting is a combination of diffused daylight coming from camera right and from the bride's left.

the left hand, for instance, the right arm should come in to meet the other at wrist level. She should hold her bouquet a bit below waist level to show off the waistline of the dress, which is an important part of the dress design. Most wedding photographers will be sure to take plenty of photographs of the bride to show the dress from all angles.

Top wedding photographers constantly review the editorial photography found in bridal magazines, both national and regional publications. Every bride is looking at these same magazines, dreaming that her wedding will look just like what she sees in these magazines. Styles, techniques, new trends and the "coolest" poses are all there to review.

A good source of poses for men is gentlemen's magazines, like *GQ* or *Esquire*. The range of poses runs from intellectual to macho and

you'll pick up some good ideas, particularly for the groom's portrait and the groom and groomsmen group.

The Bride. Most brides will spend more money on their wedding dress and more time on their appearance than for any other occasion in their entire lives. Because of this, the photographs made will become a permanent record of how beautiful she looked on this day.

Since the bride's gown is such a meaningful part of the wedding, many photographers will create a series of details of it. Make sure not to ignore the back of the dress—dress designers incorporate as much style and elegance into the back of the dress as the front. Almost as

important is a series of details of the bridesmaid's dresses.

A beautiful and popular style of wedding portrait is the bride photographed through her veil, which acts like a diffuser and produces romantic, attractive results. Lighting should be from the side rather than head-on to avoid shadows on the bride's face caused by the tulle.

Lighting. Weddings will be photographed in almost every kind of light imaginable—open shade, bright sun, dusk, dim room light and every combination in between. Subjects may also be backlit, side-lit, top-lit or front-lit. The savvy wedding photographer must feel at home in all these different lighting

situations and know how to get great pictures under these conditions. Learning to control, predict and alter these various types of light will allow the photographer to create great wedding pictures all day long and into the evening.

While the basic lighting patterns do not have to be used with absolute precision, it is essential to know what they are and how to achieve them. If, for instance, you are photographing your bride and groom outdoors, you can position a single key light to produce the

ABOVE—Tony Florez created this mysterious and innovative bridal portrait by employing shadows and tilting the camera. The lighting is vintage Hollywood, a perfect butterfly pattern that elongates the eyelashes and washes the bride in glamour. This is a portrait that every modern bride would envy. LEFT—Martin Schembri made this bride look incredibly lovely using the focused light streaming in through stained glass windows. The light created a beautiful loop pattern. To preserve the drama of the light, no fill was used. Martin chose an interesting vantage point and composition that makes the light appear as though it's emanating from the bride.

 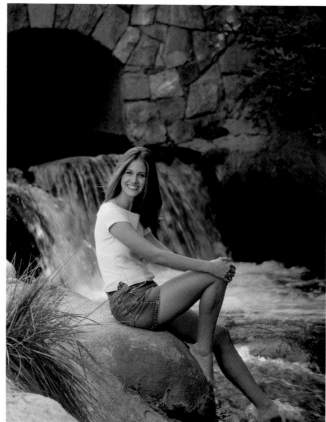

desired lighting pattern and ratio and use the ambient light (shade or sun as backlighting) as the fill light. No other lights are needed to produce one of the five basic portrait lightings. Use of reflectors, instead of an independent fill light, may accomplish much the same thing in terms of controlling light.

● THE SENIOR PORTRAIT

Teens and seniors are the fastest growing segment of the portrait photography market, and for good reason. They are often affluent, they are up to date on the latest trends in style and clothing, and senior-age kids are approaching the height of their physical attractiveness. What better time to have a series of portraits made?

In many cases, senior portraits are done by the schools on picture day—but that is not the type of senior portraiture referred to here. Many studios now offer high-end, very hip, upscale senior sittings that

allow the kids to be photographed with their favorite things in their favorite locations. For instance, a senior's car, usually a treasured possession, is a prime prop that can be included in these sessions. Often, senior sessions will involve the subject's friends and favorite haunts. Sometimes, in the case of senior girls, they will want to be photographed in a fashion or glamour pose, wearing something pretty racy—like what they see on MTV. This is all part of the process of expressing their individuality and becoming an adult. Instead of resisting it, many smart photographers are now catering to it. Of course, with these types of sessions, it is important to have a pre-shoot meeting with one or both parents to determine what is expected.

Photographing seniors and teens requires that you be something of a psychologist. You must be sensitive to the particular concerns that teens have about the acceptance of their

LEFT—Teenagers love to be photographed with their favorite things—in this case, the young girl's dog. Ira Ellis made this portrait in the courtyard of his studio, where he has a permanent set resembling the French Quarter. At most times during the morning, reflected sunlight bouncing off the other side of the courtyard gives him a beautiful wraparound portrait light that requires no fill. RIGHT—Seniors are discriminating and know good photos from bad ones. They like genuine, flattering poses in which they look great and like themselves. Jeff Smith is a master at photographing seniors, whether in formal attire or "kickin' back" clothes, as shown here.

peers. They want to feel that they fit within the mainstream of others their own age. While they may be nonconformists in terms of the adult world, they are part of the "scene" in their own world. One must be aware of the latest trends in both clothing and hairstyles, and attempt to be sensitive to their requests for particular settings and poses. Teens need to feel that they

have control. The photographer's job is to suggest possibilities and give them reinforcement and reassurance that they look great.

Most successful senior photographers really enjoy kids of this age group. They find that if they treat teens like adults, the kids will usually respond like adults—or at least try to. Although some teens are introspective and moody, most still enjoy being asked about their lives, their hobbies, their likes and dislikes—and this is a way to involve them in the photography session.

Seniors like activity and bright colors in their portraits. Unusual backgrounds and props like brightly colored geometric shapes and large numbers that spell out their class year seem to be popular. Many also like the latest music blaring in the background as they pose. Good senior photographers will make the sitting as much fun as possible.

Senior girls especially want to be photographed in a variety of outfits—from formal to casual clothes. Often, a meeting is scheduled with the teen and his or her parents before the photo session to discuss this aspect of the shoot. Typically, photographers suggest a formal outfit (like a tux or formal dress), a casual outfit (shorts and a tee-shirt), an outfit that is cool (one that they feel they look really great in), and an outfit that represents their main interest (a baseball jersey and cap, cheerleader's outfit, etc.).

The good senior photographer will provide as much information as possible, either in a consultation, brochure or web site, to tell the senior what to expect on the day of the sitting. In many instances, this is the first time that the young adult will have ventured into a photographer's studio on their own. If it is a positive experience for them, it is often the beginning of a relationship with the photographer and the entire family.

Posing. Good senior and teen photographers will provide a wide variety of poses, some of them relaxed and trendy, some more for-

RIGHT—Ryan Romaguera, son of well known senior photographer Ralph Romaguera, created this composite image. Ryan photographed his subject on the four-wheeler and later posterized the image to disguise slight camera blur. He then dropped in the portrait of Gerard leaning over his handlebars. In Ryan's words, "I wanted the combined image to show the total personality of the student." BELOW—Ira and Sandy Ellis have perfected the teenage fantasy portrait, a technique that their studio also employs with small children. The portrait is made with real props and then brought into Photoshop where a background and edge treatment are added. Retouching is often done at this stage, as well. The duo do all their own Photoshop work and it has made a big difference in the price range that their senior portraits command.

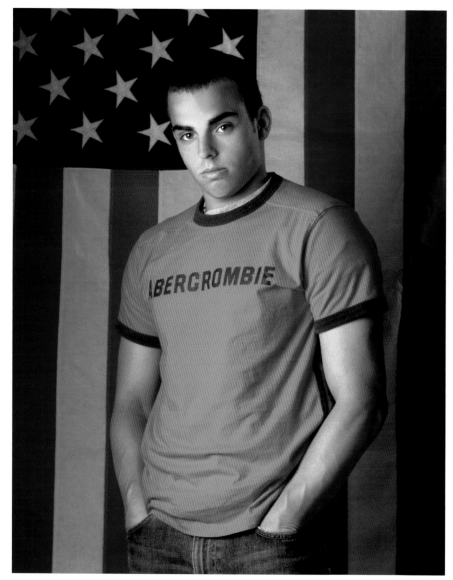

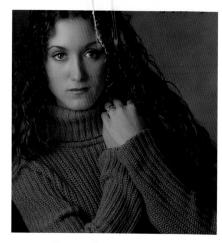

ABOVE—Tim Kelly creates meaningful poses that the subject helps come up with without really acknowledging it. In this studio portrait, Tim wanted to show off the girl's beautiful hair. Clasping her hands and bringing them in close to her face gave Kelly the pose he wanted. LEFT—Ralph Romaguera's studio photographed this athletic teen in studio wearing his favorite tee-shirt and jeans and in a very relaxed pose. Ralph thinks it's essential that kids look like themselves. The American flag as a background was a nice touch.

mal. While senior-age kids often react poorly to traditional posing, these poses help you retain some structure and stay within the realm of portraiture—and the resulting portraits also tend to please the parents. Most kids are cooperative once the session gets going.

The best way to approach posing is to strive for a natural look. With boys, find a pose that they feel comfortable in and then refine it. Find a comfortable seat, even if it's on the floor of the studio, and then modify the pose to make it a professional portrait. Senior girls, like women of all ages, want to be photographed at their best, looking slim and beautiful. Look for poses

that flatter the young woman's figure and make her look her most attractive.

Digital photography can work well at these sessions. Rick Pahl, a successful senior photographer from Florida, shoots digitally and then shows the teen the image on the camera back immediately after it is taken. This gives the young person instant feedback and it also makes them feel involved in the picture-making process.

Props. Kids should be encouraged to bring in some of their favorite things to the shoot—including their pets. This will help reveal their personalities even more, and the presence of their favorite

things will help them feel more relaxed and at home.

When a senior looks through their proofs they will expect to see a variety of poses and looks—as well as some style and sensitivity in the images. Ultimately, whether the poses are casual or formal, they will probably like the images in which they look themselves and the ones that reveal their true natures.

The following section is devoted to portrait photographers who don't fit a single niche, like "child portraiture" or "executive portraiture." Their work is acclaimed and unique and, as such, deserves its own place in this book.

● KEVIN KUBOTA: BEAUTIFUL ENERGY

Kevin Kubota says that his two favorite subjects to photograph are brides and expectant mothers. When he actually started to think about it, he realized that these are the two times in a woman's life when she is the most beautiful—but in a way that transcends the simple bounds of physical appearance. Kevin believes that these women radiate an energy—a distinctly feminine energy—that is outside the norm of everyday life. This "aura," as he refers to it, is magical and completely unique to women.

Kubota's images of expectant mothers are full of life, and joy, and fun. He will adorn his subjects in leaves, colorful temporary tattoos (of leaves), garlands and other unusual props, but always apparent in his photographs are the smiling eyes that that radiate the joy they are experiencing at this time in their lives.

For Kevin Kubota the energy of the expectant mother sparks his imagination and he begins to realize how that beautiful energy can be expressed. He envisions her in a romantic or dramatic setting. Kevin shares these ideas with his subjects to see if they feel right for her personality, and usually he's not too far off. Occasionally he finds his ideas are not what the woman expected, but with his charm and imagination

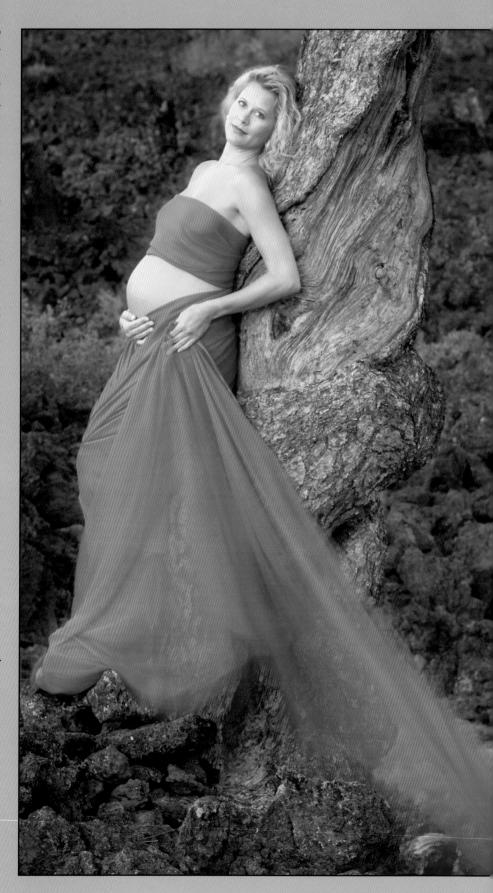

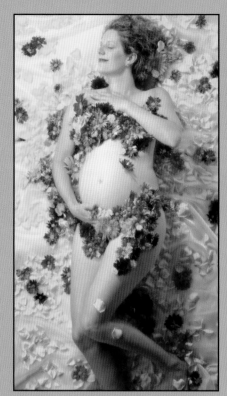

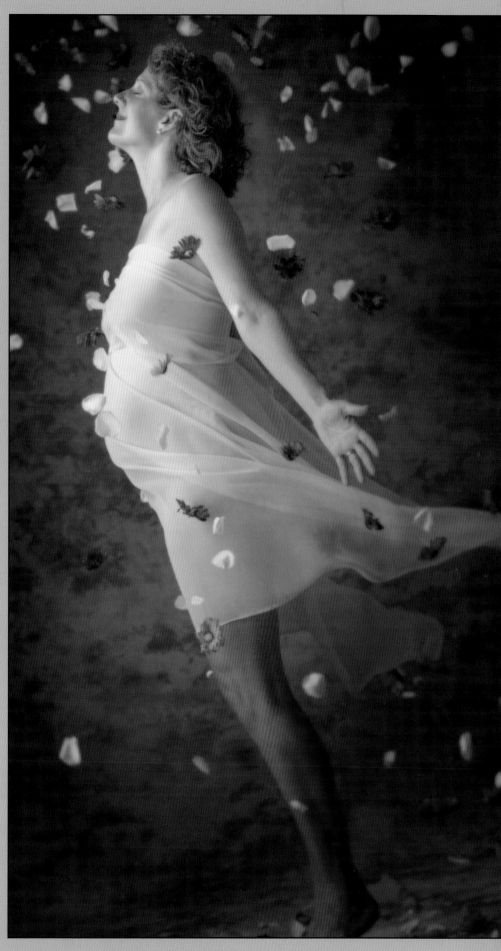

he makes contact with her, perhaps revealing a side of her that was not always easy to express or allowed to escape.

Kevin sees the expectant mother's energy as the culmination of his own inner sense of true beauty.

● DAVID ANTHONY WILLIAMS:
MASTERWORK

"Twenty-odd years ago, I had this idea of producing images that were in homage to the old masters. Yes, I know other people did it too. At the time, a photographer whom I respected told me I'd never make any money doing it. I listened.

"About five years ago I was trying to re-discover why I wanted to be a photographer and I found myself studying my art history hard and creating these images I just love doing.

"The first one I ever did anything with won me the Australian leg of the Hasselblad 'Homage to the (Old) Masters' with a picture of my friend Yervant. Other images received high scores in the industry's National Print Awards.

"When I was approached by Kodak to be the 'mentor' in Australia for their new range of Portra professional color negative films, I suggested that the last thing photographers wanted to see was portraits they do everyday—regardless of how good. They want to be visually stimulated.

"Kodak commissioned me to design and produce a series of five portraits, all of prominent Australian master photographers. I wanted the pictures to work in much the same way as the sublime image of the Native Americans in profile that Nick Vedros produced for Kodak T-Max. That superb image is seared into my memory.

"I wanted the pictures to produce a triple-take response from the photographer viewing them—that is, firstly responding to the wonderful costuming, color and quality; secondly, realizing that it's a well known industry figure; and thirdly, seeing the photographic element in each image.

"Although I certainly picked costumes and themes to suit the appearance of the subject, the final images reflected their personalities as well. This series has proved extremely popular.

"So my comment to anyone from all this is 'Do what you love—not always what sells!'"

BELOW LEFT—*The Illustrative Photographer as a Frontiersman 1817.* This was part of a series David Williams made using (AIPP) master photographers from around Australia. The subject is Jeff Moorfoot, M.Photog., who is indeed an illustrative photographer and lecturer. That is his real hair, by the way. Williams says, "Subconsciously, I seem to have designed the images to suit the personalities of the photographers, although I wasn't aware of that at the time. I was more concerned about using their unique outward appearances." BELOW RIGHT—This is an homage to Antony van Dyck's *Earl of Arundel.* Richard Bennett, M.Photog., is an ex-National AIPP president and chairman of the Awards committee. He is a highly respected "commander." FACING PAGE—Doug Spowart, M.Photog., is a legend in the print-awards system in Australia, and a fine-art photographer with a incredibly eclectic taste and knowledge. He is also an educator and lecturer.

"These are exciting and unusual times. There has been more technological change that affects our industry in the last few years than perhaps the entire past history of photography. The change is much more than camera, film, and darkroom improvements. Digital imaging is a fundamental change in the way that individual elements of an image are recorded, potentially altered and then reassembled in the form of a print or other derivation.

"Artistry has always been a priority for me. Along with camera techniques, I used to invest many hours in the darkroom to create unique images. Local diffusion, elongating part of an image, texture screens, and exposing multiple images on one print were a few routine techniques I utilized. After the printing, I often would further alter the presentation of the portrait with various levels of oil-paint enhancements. I used paints both to increase the longevity of the print and to provide more unusual portrait presentations than photography alone could offer. The resulting images were more evocative. I enjoyed what I was doing and my clients both appreciated and paid for my efforts.

"Digital imaging advances creativity. More often than not I have replaced the traditional darkroom and print-enhancement techniques with a stylus and tablet. It is the level of control, surgical in its preci-

sion, that I am most impressed with. We can affect even the smallest areas of an image in a multitude of ways. On the simplest of applications, an image can be enhanced for exposure problems, or to remove unwanted background objects, or even to replace and add people from different images. More magically, it offers an artist the ability to reinterpret and process an image in so many directions. Mood and symbolism can more easily dramatize a portrait statement or shift the image from the literal to the illustrative or even surreal.

"Digital imaging is efficient. A virtual playground for creativity, digital imaging offers the added benefit of saving and reusing many elements of an image. This is a huge asset to us. Specialized backgrounds, flowing fabrics, and fantasy creatures are a few elements that I reuse again and again in various combinations as components of a future creative project. The resulting efficiency allows a much greater variety that we can offer our customers and a substantial reduction in our cost of production.

"However, it is only the tools that have changed. Despite this Renaissance in the industry, my customer, aesthetic, and business goals remain the same. Customers still want emotion, quality and uniqueness. I still wish to continue to grow artistically and to enjoy what I do for a living. I still wish to focus my business efforts and increase profits. Although the customer and business advantages of digital imaging are indisputable, I must selfishly admit that it is the opportunity for creativity and self-expression that excites me the most and renews my enthusiasm in photography as an art media. Life is good."

Gene Martin has had a camera in his hands for as long as he can remember. Seeing the film *Blow Up* as a teenager had a major influence on this New York City image-maker's career, exposing him to the excitement of photography and the equipment involved. Like the photographer in the movie, Martin is a devout fan of Hasselblad and Nikon cameras to this day.

Martin studied photography in college, but after college he had a fifteen-year career as a professional guitarist. In 1985, he returned to photography, specializing in enter-tainment personalities, particularly jazz musicians. He soon became one of the leading portraitists of jazz musicians in America, having photographed virtually everyone in the jazz community—Dizzy Gillespie, McCoy Tyner, Stan Getz, and Elvin Jones—to name just a few. What makes Gene Martin in demand is that each of his portraits tells a story that encompasses the essence of the individual he's photographing, making his work ideal for album covers.

Martin employs bold colors and often uses special effects to imply motion. In a recent interview he said, "My aim is to explore creative image-making as a form of illustration. Whether it be blind pianist Marcus Roberts' musical vision or Canadian trumpeter Ingrid Jensen's embrace of American jazz, my goal is to tell a story about the performer in a single image."

To illustrate blind pianist Marcus Robert's 'vision' in his music for a cover of *JazzTimes*, Martin photographed him while reflecting a 6' long painted poster of piano keys in mirrored eyeglasses. The shot was done in a Washington, DC hotel room and has since run in *People*, *Newsweek*, and a Hasselblad advertisement.

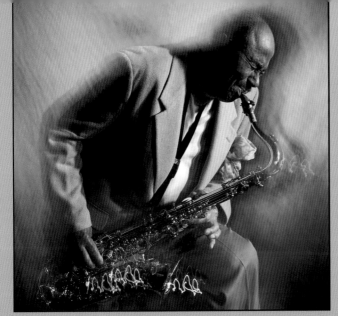

ABOVE—Saxophonist Benny Golson was photographed for the cover of his *That's Funky* CD. A combination of strobe, tungsten light, camera-shake and background movement were used to illustrate excitement. TOP RIGHT—To simulate a feeling of sunset for this portrait of Michael Brecker, Martin used a frontal light with a large softbox with kickers gelled with CTO filters from the sides behind the subject. A set-design company painted the background. RIGHT—To show jazz legend McCoy Tyner's virtuosity on the piano he was photographed commanding the keys with a combination of strobe, tungsten lights and gels. A Hasselblad and 50mm wide-angle Zeiss lens were used to make the image.

Most of his portrait sessions are short (some may take only ten minutes), so he has learned to shoot fast. That's why pre-visualization and creating a viable concept beforehand are so important to Martin's creative process. A good example of his animated, conceptual style is his signature portrait of virtuoso jazz pianist, McCoy Tyner, whose blazing hands are literally lighting up the keyboard. Martin pre-tested every aspect of this image before he went on location to a New York City jazz club, where he executed the image in under ten minutes. Martin calls this a "signa-ture" image because it has been reproduced many times around the world, and incorporates the essence of his style and technique.

Gene Martin suffered a stroke in December 2001, leaving him blind in his left eye—the eye he uses for shooting. Although he has regained partial sight in that eye, he is mastering shooting with his right eye, believing that, after a week or so of feeling sorry for himself, he had better get on with things.

A true New Yorker, the one thing that may have changed about Martin since the stroke is his knowledge that he can do what he does anywhere, and has always had an urge to live in the Southwest. He believes his conceptual style will work anywhere.

Phillip Charis has spent a lifetime perfecting the photographic portrait. His love for the art of photography drew him to the museums to study the works of the old masters, formulating a style that was to become the cornerstone of his career. Charis' portraits possess the elements of style and expressions that are compelling and sincere.

His works are decidedly low-key—rich in tonality and dark vibrant tones that dramatize the features and accentuate the pose. Each Phillip Charis portrait contains a lifetime of experience, and in that expertise is a skill and caring sensitivity towards each of his subjects.

If Phillip Charis never did anything other than his near-life-size portraits, he would still be remembered as one of the great portrait artists of this or any other time. But in 1997, his creative energies were completely revitalized and rechanneled in a new direction, thanks to the digital revolution. This technology was as significant to Charis as the birth of the color negative back in the 1950s.

After some research he purchased a computer, a scanner and a printer and all of this was installed in a room to create a digital laboratory. Phillip, who is not a natural "techie" hired a guru to help teach him the rudiments of the computer. After a month of learning the computer he was able to create, with the

new technology, complex and subtle ideas that existed in his imagination for many decades.

Pulling from this body of work of forty-six years, he looked beneath the surface of individual faces and transformed a highly diverse range of expressions into an abstract art form.

His first attempt, *Golden Girl*, which appears here, is in now housed at the Los Angeles County Museum of Art. His collection now boasts 180 images, all faces where he has looked beneath the surface and has created what is, in his imagination, a collection of faces of abstract art.

Phillip Charis still believes in the core philosophy that has made him a successful portrait artist. "The

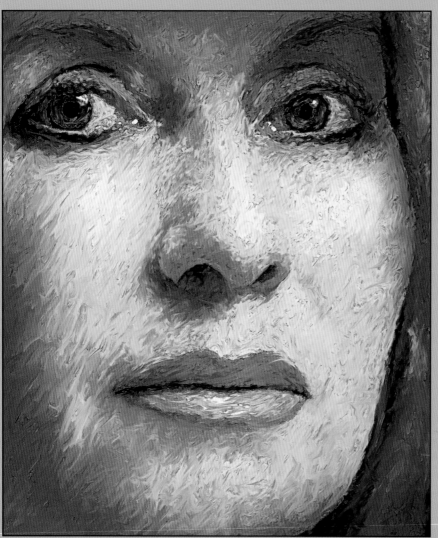

LEFT—The use of Impressionist color and brush strokes make this 2001 creation a masterpiece. BELOW—The deletion of integral tonality in the portrait makes this an unusual Charis original. Created in 2001.

ABOVE—In this remarkable Phillip Charis print, only the mask of the face is illuminated and the steps of the transitions from shadow to highlight are abbreviated. The powerful expression is both vital yet vulnerable. It is an image that we cannot look away from. RIGHT—*Golden Girl*, Phillip Charis' first serious digital effort, created after only a month of computer training. The print is already a part of the Los Angeles County Museum of Art's permanent collection.

portrait painters of the past created a legacy for us. The Rembrandts, the Gainsboroughs, and the Sargents of the portrait-painting world have passed the gauntlet of fine portraiture to us. It is our obligation to continue on with that tradition over three-hundred years in the making."

As always, Charis continues to seek the ideal—the perfect portrait photograph. Just as he relished the introduction of the large-format photographic print, a development that revolutionized his art, so he sees the digital revolution. He is determined to develop the perfect digital print that will bridge the gap between the photographer and the painter without losing the perfect likeness of the subject. To date, his experiments are close but are not more beautiful than what has been created for so many years with film and photographic paper. With different applications on the computer he is convinced that he will eventually achieve the perfect portrait that, so far, has only lived within the fertile imagination of the artist. The final output can be transferred to canvas via a photographic print or directly onto canvas with an Iris giclée printer, allowing a new art form to be born.

IT'S ALL ABOUT RELATIONSHIPS

Michael Taylor is the owner of Taylor Fine Portraiture in Pasadena, CA, an affluent suburb of Los Angeles. For him, portrait photography is all about developing relationships with clients that enable him to capture something extra in his photographs. One of the first things Michael Taylor learned, as a professional is that you "have to establish a connection with everyone." Taylor says, "It's easy to photograph someone who's beautiful, or in a great environment. But often you have to photograph people who are emotionally or physically difficult to deal with, and still make something wonderful happen."

More than half of Taylor's portraiture is location-based. "That's what I'm known for," he says. Taylor loves the challenge of doing location work and the fact that it makes every portrait unique. He believes that homes and outdoor settings tend to allow more of a sense of dimension. And people—especially kids—are more relaxed in a familiar environment. Michael Taylor likes the sense of history and likes capturing children where they're growing up. "If we can capture something representational, with some emotion and history all in one image, that's really wonderful. That's what I'm after," Taylor says.

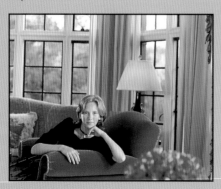

Generally, Taylor starts with formal images, then encourages the subject to change clothes for more informal pictures. Taylor tends to use just two lights (a key and a fill) whenever possible, and employs ambient light as the background or hair light. This way, the ambient light and the natural surroundings of the home or location become a big part of each portrait he makes. A typical location sitting is about thirty exposures on medium format (6x7cm or 6x4.5cm film).

If Michael Taylor's work looks consistent, it is because his finest

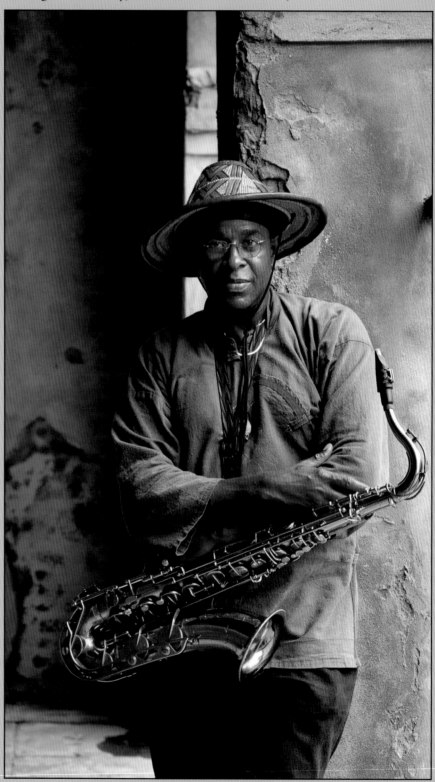

images display a sense of relaxed elegance. There's a sense of ease—not a rigidity or stiffness. He strives to bring the best emotionally out of his subjects, especially children, and is fond of portraying a sense of personality and pride.

Taylor Fine Portraiture shoots around 450 sittings a year. The business is evenly divided between children's portraits, family portraits, and corporate/PR work. He stays away from weddings. Taylor wants to add seniors to the business mix, drawing on the families he has photographed throughout the years.

Michael Taylor's portraits, as shown here, display a uniqueness in that each subject seems to be completely involved with the process of portraiture, and that involvement is conveyed in terms of lively animated subjects.

Glossary

Abrading tool. A needle-tipped retoucher's tool used to remove pin-holes and spots on negatives and prints.

Angle of incidence. The original axis on which light travels. The angle of reflection is the secondary angle light takes when reflected off of some surface. The angle of incidence is equal to the angle of reflection.

Balance. A state of visual symmetry among elements in a photograph.

Barebulb flash. Portable flash unit with a vertical tube that fires the flash illumination 360 degrees.

Barn doors. Black, metal folding doors that attach to a light's reflector; used to control the width of the beam of light.

Black flag. Light-blocking card that is supported on a stand or boom and positioned between the light source and subject to selectively block light from portions of the scene. Also known as a gobo.

Bounce flash. Bouncing the light of a studio or portable flash off a surface such as a ceiling or wall to produce indirect, shadowless lighting.

Box light. A diffused light source housed in a box-shaped reflector. The bottom of the box is translucent material; the side pieces of the box are opaque, but they are coated with a reflective material such as foil on the inside to optimize light output.

Broad lighting. One of two basic types of portrait lighting in which the key light illuminates the side of the subject's face that is turned toward the camera.

Butterfly lighting. One of the basic portrait lighting patterns, characterized by a high-key light placed directly in line with the line of the subject's nose. This lighting produces a butterfly-like shadow under the nose. Also called paramount lighting.

Catchlight. The specular high-lights that appear in the iris or pupil of the subject's eyes reflected from the portrait lights.

Cross-lighting. Lighting that comes from the side of the subject, skimming facial surfaces to reveal the maximum texture in the skin. Also called side-lighting.

Cross processing. Developing color negative film in color transparency chemistry and vice versa (developing transparency film in color negative chemistry).

Cross shadows. Shadows created by lighting a group with two light sources from either side of the camera. These should be eliminated to restore the "one-light" look.

Depth of field. The distance that is sharp beyond and in front of the focus point at a given f-stop.

Depth of focus. The amount of sharpness that extends in front of and behind the focus point. Some lenses depth of focus extends fifty percent in front of and fifty percent behind the focus point. Other lenses may vary.

Diffusion flat. Portable, translucent diffuser that can be positioned in a window frame or near the subject to diffuse the light striking the subject.

Dodging. darkroom printing technique in which specific areas of the print are given less print exposure by blocking the light to those areas of the print, making those areas lighter.

Dope. Retouching medium that is often applied to negatives to give them a suitable retouching surface.

Dragging the shutter. Using a shutter speed slower than the X-sync speed in order to capture the ambient light in a scene.

E.I. Otherwise known as exposure index. The term refers to a film speed other than the rated ISO of the film.

Etching. A subtractive retouching technique used for selectively reducing density in an area of the negative.

Fashion lighting. Type of lighting that is characterized by its shadowless light and its proximity to the lens axis. Fashion lighting is usually head-on and very soft in quality.

Feathered edge. Also known as the penumbra; the soft edge of the circular light pattern from a light in a parabolic reflector.

Feathering. Misdirecting the light deliberately so that the edge of the beam of light illuminates the subject.

Feminine pose. A pose characterized by the head tilted toward the high shoulder.

Fill card. A white or silver-foil-covered card used to reflect light back into the shadow areas of the subject.

Fill light. Secondary light source used to fill in the shadows created by the key light.

Flash-fill. Flash technique that uses electronic flash to fill in the shadows created by the main light source.

Flash key. Flash technique in which the flash becomes the main light source and the ambient light in the scene fills the shadows created by the flash.

Flashmeter. A handheld incident meter measures both the ambient light of a scene and when connected to the main flash, will read flash only or a combination of flash and ambi-

ent light. They are invaluable for determining outdoor flash exposures and lighting ratios.

Focusing an umbrella. Adjusting the length of exposed shaft of an umbrella in a light housing to optimize light output.

Foreshortening. A distortion of normal perspective caused by close proximity of the camera/lens to the subject. Foreshortening exaggerates subject features—noses appear elongated, chins jut out, and the backs of heads may appear smaller than normal.

45 degree lighting. Portrait lighting pattern characterized by a triangular highlight on shadow side of face. Also known as Rembrandt lighting.

Fresnel lens. The glass filter on a spotlight that concentrates the light rays in a spotlight into a narrow beam of light.

Full-length portrait. A pose that includes the full figure of the model. Full-length portraits can show the subject standing, seated, or reclining.

Furrows. The vertical grooves in the face adjacent to the mouth. Made deeper when the subject smiles; often called laugh lines.

Gobo. Light-blocking card that is supported on a stand or boom and positioned between the light source and subject to selectively block light from portions of the scene. Also known as a black flag.

Head-and-shoulder axis. Imaginary lines running through shoulders (shoulder axis) and down the ridge of the nose (head axis). Head and shoulder axes should never be perpendicular to the line of the lens axis.

High-key lighting. Type of lighting characterized by low lighting ratio and a predominance of light tones.

Highlight brilliance. Refers to the specularity of highlights on the skin. A negative with good highlight brilliance shows specular highlights (paper base white) within a major highlight area. Achieved through good lighting and exposure techniques.

Hot spots. Area of the negative that is overexposed and without detail. Sometimes such areas are etched down to a printable density.

Incident light meter. A handheld light meter that measures the amount of light falling on its light-sensitive cell.

Key light. The main light in portraiture used to establish the lighting pattern and define the facial features of the subject.

Kicker. A backlight (a light coming from behind the subject) that highlights the hair or contour of the body.

Lead-in line. In compositions. a pleasing line in the scene that leads the viewer's eye toward the main subject.

Lighting ratio. The difference in intensity between the highlight side of the face and the shadow side of the face. A 3:1 ratio implies that the highlight side is three times brighter than the shadow side of the face.

Loop lighting. A portrait lighting pattern characterized by a loop-like shadow on the shadow side of the subject's face. Differs from paramount or butterfly lighting because main light is slightly lower and farther to the side of the subject.

Low-key lighting. Type of lighting characterized by a highlighting ratio and strong scene contrast as well as a predominance of dark tones.

Main light. Synonymous with key light.

Masculine pose. A pose characterized by the head tilted toward the low shoulder.

Matte box. A front-lens accessory with retractable bellows that holds filters, masks, and vignettes for modifying the image.

Modeling light. A secondary light mounted in the center of a studio flash head that gives a close approximation of the lighting that the flash tube will produce. Usually high intensity, low-heat output quartz bulbs.

Over-lighting. Main light is either too close to the subject, or too intense and over-saturates the skin with light, making it impossible to record detail in highlighted areas. Best corrected by feathering the light or moving it back.

Parabolic reflector. Oval-shaped polished dish that houses a light and directs its beam outward in an evenly controlled manner.

Paramount lighting. One of the basic portrait lighting patterns, characterized by a high-key light placed directly in line with the line of the subject's nose. This lighting produces a butterfly-like shadow under the nose. Also called butterfly lighting.

Penumbra. The soft edge of the circular light pattern from a light in a parabolic reflector. It is also known as the feathered edge of the undiffused light source.

Perspective. The appearance of objects in a scene as determined by their relative distance and position.

Pinholes. Small, clear marks on the negative that print black on the print.

Push-processing. Extended development of film, sometimes in a special developer, that increases the effective speed of the film.

Reflected light meter. Meter that measures the amount of light reflected from a surface/scene. All in-camera meters are of the reflected type.

Reflector. Same as fill card. Or, a housing on a light that reflects the light outward in a controlled beam.

Rembrandt lighting. Same as 45-degree lighting.

Rim lighting. Portrait lighting pattern where the key light is behind the subject and illuminates the edge of the subject. Most often used with profile poses.

Rule of thirds. Format for composition that divides the image area into thirds, horizontally and vertically. The intersection of two lines is a dynamic point where the subject

should be placed for the most visual impact.

Scrim. A panel used to diffuse sunlight. Scrims can be mounted in panels and set in windows, used on stands, or they can be suspended in front of a light source to diffuse the light.

Seven-eighths view. Facial pose that shows approximately seven-eighths of the face. Almost a full-face view as seen from the camera.

Shadow. An area of the scene on which no direct light is falling making it darker than areas receiving direct light; i.e., highlights.

Short lighting. One of two basic types of portrait lighting in which the key light illuminates the side of the face turned away from the camera.

Slave. A remote triggering device used to fire auxiliary flash units. These may be optical, or radio-controlled.

Soft-focus lens. Special lens that uses spherical or chromatic aberration in its design to diffuse the image points.

Specular highlights. Sharp, dense image points on the negative. Specular highlights are very small and usually appear on pores in the skin.

Split lighting. Type of portrait lighting that splits the face into two distinct areas: shadow side and highlight side. The key light is placed far to the side of the subject and slightly higher than the subject's head height.

Spotmeter. A handheld reflected light meter that measures a narrow angle of view—from 1 degree to 4 degrees, usually.

Spots. Spotlights; a small sharp light that uses a Fresnel lens to focus the light from the housing into a narrow beam.

Straight flash. The light of an on-camera flash unit that is used without diffusion; i.e., straight.

Subtractive fill-in. Lighting technique that uses a black card to subtract light out of a subject area in order to create a better defined lighting ratio. Also refers to the placement of a black card over the subject in outdoor portraiture to make the light more frontal and less overhead.

Three-quarter-length pose. Pose that includes all but the lower portion of the subject's anatomy. Can be from above knees and up, or below knees and up.

Three-quarter view. Facial pose that allows the camera to see three-quarters of the facial area. Subject's face usually turned 45 degrees away from the lens so that the far ear disappears from camera view.

Tension. A state of visual imbalance within a photograph.

Tooth. Refers to a negative that has a built-in retouching surface that will accept retouching leads.

TTL-balanced fill flash. Flash exposure systems that read the flash exposure through the lens and adjust flash output to compensate for flash and ambient light exposures, producing a balanced exposure.

Triangle base. Combination of head, torso and arms that creates the basic compositional form in portraiture.

Two-thirds view. A view of the face that is between three-quarter view and seven-eighths view. Many photographers do not recognize these distinctions—anything not a head-on facial view or a profile is a two-thirds view.

Umbra. The hot center portion of the light pattern from an undiffused light in a parabolic reflector.

Umbrella lighting. Type of soft, casual lighting that uses one or more photographic umbrellas to diffuse the light source(s).

Vignette. A semicircular, soft-edged border around the main subject. Vignettes can be either light or dark in tone and can be included at the time of shooting, or added later in printing.

Visual weight. A compositional element that place visual emphasis on it.

Watt-seconds. Numerical system used to rate the power output of electronic flash units. Primarily used to rate studio strobe systems.

Wraparound lighting. Soft type of light, produced by umbrellas, that wraps around subject producing a low lighting ratio and open, well-illuminated highlight areas.

X sync. The shutter speed at which focal-plane shutters synchronize with electronic flash.

Zebra. A term used to describe reflectors or umbrellas having alternating reflecting materials such as silver and white cloth.

Other Books from
Amherst Media